ARCHITECTURE

OF SILENCE

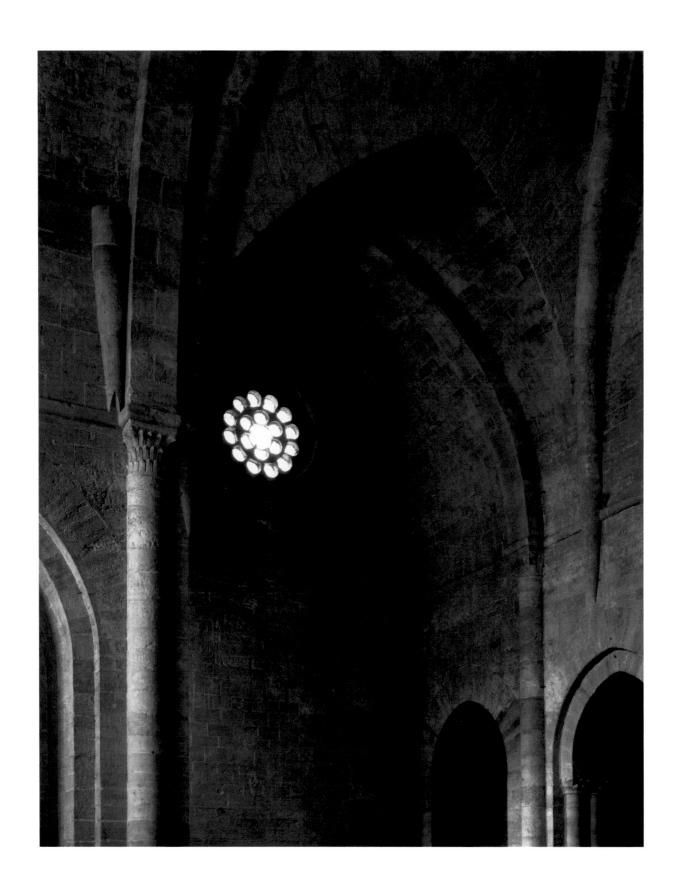

ARCHITECTURE OF SILENCE

CISTERCIAN ABBEYS OF FRANCE

PHOTOGRAPHS BY

DAVID HEALD

TEXT BY

TERRYL N. KINDER

HARRY N. ABRAMS, INC.

PUBLISHERS

For Regina, Alexander, and Rebecca

The publication of this book
has been supported in part by a grant from the
EASTMAN KODAK COMPANY.

Library of Congress Cataloging-in-Publication Data

Heald, David, 1951–
 Architecture of silence : Cistercian abbeys of France/photographs by David Heald;
introduction by Terryl N. Kinder.
 p. cm.
 Includes bibliographical references.
 ISBN 0–8109–4116–3 — ISBN 0–930407–51–2 (limited ed.)
 1. Architectural photography — France. 2. Abbeys — France — Pictorial works.
 3. Cistercian architecture — France. I. Title.
TR659 .H42 2000
779'.444—dc21 00–26655

Printed and bound in Italy

Produced in association with
PARABOLA BOOKS, NEW YORK

Harry N. Abrams, Inc.
100 Fifth Avenue, New York, N.Y. 10011
www.abramsbooks.com

CONTENTS

ACKNOWLEDGMENTS

THIS BOOK has come to fruition with the encouragement, support, and efforts of many people. I am deeply indebted to my parents, Barbara and Morrell Heald, who instilled in me a love of books, and who long ago introduced me to ancient and medieval architecture across Europe and Asia. I am particularly grateful to Nicholas Hlobeczy who first pointed out to me the profound possibilities of the photographic medium. In addition, over the years I have received support and wise counsel on all aspects of this project from: Marielle Bancou and William Segal, Linda Butler, Paul Caponigro, William Clift, Lee Ewing, Ellen Labenski, Roger Lipsey, Robert O'Brien, Maria O'Brien, Maria Pallante, Barry Perlus, Thomas Skove, Barney and Laura Taxel, and David Ulrich.

My photographic sojourns throughout France and access to numerous sites were facilitated and made richer through the hospitality and generosity of many people. I would specifically like to thank: the Prior and community of Sénanque, M. Nicolas d'Andoque de Sériège, M. and Mme. Hubert Aynard, Mlle. Hélène Blanchot, Marie and Antoine Dalbard, Yves Husson, Camille and Marie-Hélène de Montalivet, and the Count and Countess Anne-Pierre de Montesquiou.

I am deeply grateful to Paul Gottlieb at Harry N. Abrams, Hervé de la Martinière at Éditions de la Martinière, and to David Appelbaum and Joseph Kulin at Parabola Books for their commitment to publish this book in the

manner which the subject deserves. Sincere thanks are also due to Michael and Stark Ward of Ward & Co. and to Patrick Talbot, Annie Cohen-Solal, Jacques Soulillou and Cecelia James-Nicoullaud at the Cultural Services of the French Embassy who first exhibited the photographs in New York and have enthusiastically supported my work in numerous ways.

I am indebted to the Eastman Kodak Company for a generous publication grant which helped to underwrite the production of this book and to Michael More, Director of International Public Relations, who saw the need to ensure that the photographs would be beautifully reproduced.

Terryl N. Kinder brings to this volume a broad understanding of the architecture and its foundation in the life of the Cistercians. It is a great privilege to have her thoughtful and illuminating essay and historical notes.

Eleanor Caponigro has brought to this project her unerring eye and a passion for making fine books. Her sensitive insights have been a guide from the beginning. Her elegant design is evident throughout these pages.

Finally I am most deeply indebted to my wife Regina who has unfailingly supported my work and endured my many absences from home with quiet understanding and love.

David Heald

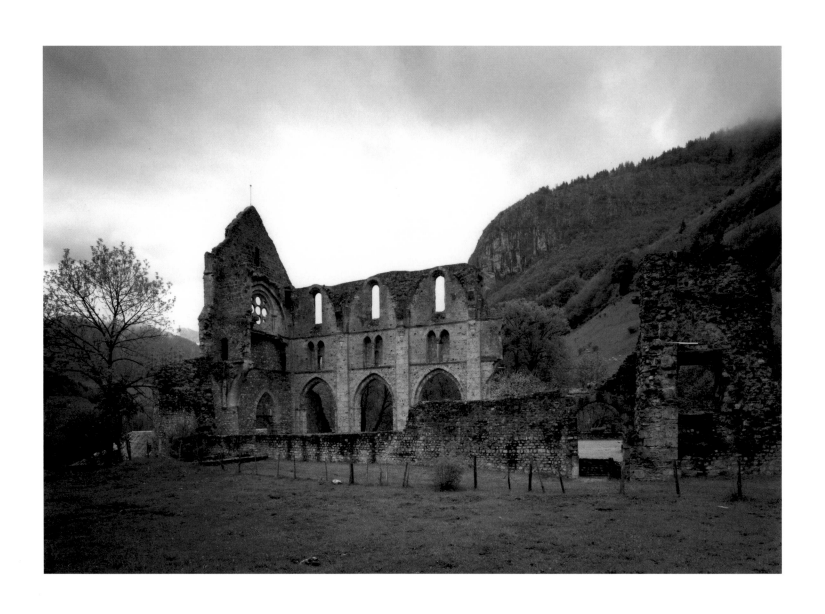

1. RUINS OF THE CHURCH, AULPS, 1995

INTRODUCTION

"Listen, my son,

to your master's precepts,

and incline the ear

of your heart."

So BEGINS THE PROLOGUE to the *Rule* of Saint Benedict, the basis of Cistercian life, and so too the monastic day unfolds inside the abbey in an ambiance of silence and decided purpose. This silence — far from being a void — is a crucible for the multifold activities designed to transform the men and women who lived within the walls so exquisitely captured in these photographs.

To visit a Cistercian abbey is to make a voyage of discovery, but not necessarily a physical voyage. It may be an inward voyage, where one discovers a part of one's own being, an inner experience from which one seldom returns unaltered. Depending on the investment made by the traveller, it may be a brief and pleasant diversion, or it may invite a change in the direction of one's life.

These photographs awaken a longing for a quieter, simpler existence. The abbeys seem to grow out of the landscape as though they had always been there, like a waterfall, an old tree, or an arched rock scooped out of a cliff eons earlier. Soft sunlight falling on a doorway, creating a muted shadow, carries the visitor to another time and place. The immediacy of the images makes us want to touch the stone, to run a hand across the

ancient surfaces, angles remarkably fresh, toolmarks still visible. The elusive riverine sites, majestic yet intimate landscapes, and compelling architecture recall a universe where harmony, peace, and balance appear to have been the substance of daily life. It is not difficult to see why Stephen Harding, the third abbot of Cîteaux, was called a "lover of the place."[1]

The indefinable magnetism present here — one might call it the attraction of God — is almost lost on the surface of today's culture. Yet in the poetry of an image one can be stirred by the same spirit that flickered in Cistercians who watched these buildings emerge from waiting rows of roughly cut stone and unmixed mortar.

<div align="center">✻ ✻ ✻</div>

There are many different ways of looking at these sites and structures. If we see an arch composed of finely-cut and fitted stones, some will ask, why was that shape chosen and not another? where was the stone quarried? how long did it take to build? how much did it cost? A vast number of technical, sociological, and philosophical questions can stimulate discussion about how an abbey may have been built, and where and when and by whom. Others are intrigued by the synergy between landscape and architecture. Still others find poetry and romantic idealism in the same walls, even projecting unfulfilled wishes and nostalgia for times past.

Cistercian architecture is experiencing a renaissance of interest. The uncluttered design of the buildings, with their harmonious proportions and subtle play of light, appeal immensely to today's visitors. The two recent nonacentenaries — the birth St. Bernard[2] (1090–1990) and the foundation

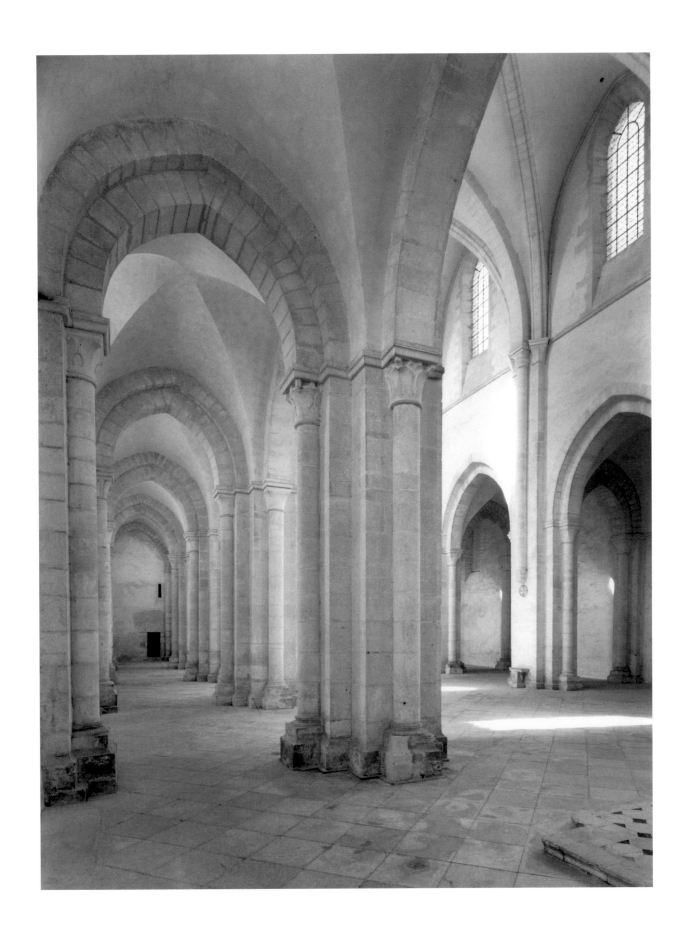

2. SOUTH AISLE AND NAVE LOOKING WEST, PONTIGNY, 1990

of Cîteaux Abbey (1098–1998) – have brought attention to this hidden way of life. The contribution of Cistercian agriculture and industry to the medieval economy has also been the object of many recent studies. The spirit of our own time – one of education, research, conservation of historic sites, development of tourism – has connected with and stimulated this curiosity and interest. Indeed, the very survival of the buildings – many under adverse geographical, sociological, or historical circumstances – is witness to an impressive phenomenon. The common will of small groups of men and women to transform a rough landscape into a place of remarkable beauty, peace, and functionalism – often sustained centuries later – presents an antithesis to the short-term flash that characterizes much contemporary culture.

One essential point in understanding early Cistercian spirituality – and therefore the *raison d'etre* for Cistercian abbeys – is that in the Middle Ages the distinction that we now draw between thinking and doing was far less clearly delineated. As Norman Tanner has said, medieval people "thought and expressed themselves largely in terms of what they did, and therefore their external activities were the key to, indeed for the most part *were* their inner piety."[3] For a medieval monk or nun, building an abbey was as much an act of spirituality as the meditation and contemplation carried out within it.

<p align="center">✢ ✢ ✢</p>

The architecture of the Cistercians cannot be divorced from the life that was led within the abbey walls, and the basis of that life is the *Rule* of Saint Benedict. The *Rule*, a guide for living in monastic community, was compiled

in the mid-sixth century by a former hermit, Benedict of Nursia.[4] An irony sometimes visited upon hermits is that their reputation for sanctity becomes so well known that people continually come to consult them or even to live with or near them. They were, it seems, a combination of confessor, spiritual guide, and social worker. In this fashion a group of disciples, wishing to live a truly Christian life, gathered around Benedict at Subiaco in southern Italy. But cenobites (monks living in community) are not hermits, and when more than one person shares a common life, a certain discipline is necessary to ensure that their goals and aspirations are carried out effectively. The *Rule* was written for this purpose. It is, on the surface, a deceptively simple book of seventy-three brief chapters, some no longer than a few lines. It quickly became very popular and was much copied, being second only to the New Testament in its widespread circulation during the Middle Ages. The *Rule* has provided a balanced guide for the cenobitic tradition for fifteen centuries and remains today the basis for much of Western monastic life.

Monks who lived by the *Rule* of Saint Benedict were called Benedictines, and in the early tenth century the *Rule* gave rise to a new family of reformed Benedictine monasteries stemming from Cluny in Burgundy.[5] The Cluniacs became a very powerful branch of Benedictine monasticism, founding hundreds of priories across Europe. During the eleventh century there was a movement of general reform throughout the Church, including numerous experiments in the interpretation of monastic life. The founding of the abbey of Cîteaux in 1098 was part of this movement.

The origins of the Cistercian Order were decidedly modest, and many details were not recorded. Abbot Robert[6] left the large Benedictine monas-

tery of Molesme that he had founded in 1075, and set out with a group of twenty-one monks to live a purer form of the *Rule* than appeared to be possible at Molesme. There is no evidence that he intended to found an Order – especially one of the magnitude of the Cistercians – and, for the first twenty years or so, Cîteaux itself was simply called the *Monasterium novum* or "New Monastery."

From the time it was first compiled until the late eleventh century when Cîteaux was founded, the *Rule* of Saint Benedict underwent numerous modifications, especially those that increased the amount of time devoted to the liturgy and decreased the time devoted to manual labor. The person primarily responsible was a second Benedict, Benedict of Aniane,[7] who died in 821. One of the elements of the Cistercian reform was to strip away many of these accretions to the *Rule* and to re-introduce manual labor into daily monastic life.

The *Rule* is a guide for living a communal life in a monastic setting, and it defines appropriate and effective behavior within the monastery. Balance is a critical factor, for not only is there a wide range of necessary activities, but an equally wide range of human beings who might not make happy neighbors unless all were oriented toward a common purpose. Fifteen of the seventy-three chapters of the *Rule* describe monastic personnel: for example, how to receive someone who wishes to become a monk, the different positions of responsibility inside the abbey, the craftsmen, the priests, the kinds of monks, and how to choose an abbot. This last is of major importance, for according to the *Rule* (ch. 2), the abbot stands in the place of Christ. He is the *abba*, or "father" of his flock, and his posi-

tion in the Middle Ages was one of great authority. He was normally elected for life by the monks of his abbey, and he was to be learned, chaste, sober, and merciful, hating vice and loving his brethren. He was not to be excitable, worried, exacting, headstrong, jealous, or over-suspicious, but prudent, considerate, discreet, and moderate. It is a formidable list of demands, and it was inevitable that few abbots achieved the ideal. Nevertheless, the position and powers of the abbot were central to Cistercian monasticism in the Middle Ages, and the movement cannot be understood without acknowledging this vital point.

Prayer and praise are an essential part of this life, and thirteen chapters of the *Rule* describe the seven monastic offices (services), all based on the Psalter, that were chanted each day, together with another lengthy office during the night.[8] A further thirty chapters concern the appropriate behavior of monks: obedience, humility, the spirit of silence, observing Lent, mistakes and punishments, travel and work, how to regard one's seniors (with respect) and one's juniors (with love). The remaining fifteen chapters concern the material side of community life: when and where to sleep, abbey property and tools, clothing and shoes, treatment of sick and elderly monks, hours for meals, quantities of food and drink, how to receive guests. Since a portion of the *Rule* was (and still is) read every day, the monks knew it by heart as well as they knew the Psalms they recited daily.[9]

＊ ＊ ＊

The very earliest Cistercian spirituality was based on poverty and charity as well as the *Rule* of Saint Benedict. As to poverty, monks possessed nothing as

individuals and were given what they needed to live (the *Rule* is very clear on this point). The abbey lands and buildings were held as common property. Yet poverty was not just a question of possessions, but of a state of mind. It also meant poverty of spirit. Certainly one had to be fed, clothed, and sheltered, but monastic life was designed to provide a release from preoccupation with material things in order to concentrate more fully on things not of this world. Nonetheless, poverty and poverty of spirit could easily be misinterpreted and lead to an unhealthy preoccupation with one's body and one's sins. The balance and beauty of Cistercian architecture were not always reflected in the physical and psychological aspects of medieval monastic life.

This was largely a result of the triumph of the Augustinian tradition. For Augustine, the fifth-century bishop of Hippo, the consequences of original sin and original guilt led inevitably to the vital need for grace and the doctrine of predestination: "Of our own power," said Augustine, "we can only fall."[10] But it also led to a tendency to identify the body with sin – the "concupiscence of the flesh" of 1 John 2:16 – and in turn mortification of the flesh could all too easily be identified with mortification of sin, and to the practice of asceticism for its own sake.

Furthermore, the idea and ideal of poverty of spirit are based on the principle that we are nothing without God. The entirety of our life and being is dependent on his life and being. This is an ancient principle, but once it is merged with the Augustinian idea of the total depravity of human beings, the results are unfortunate. According to Psalm 8:5, we are created only a little lower than the angels, but medieval monks and nuns

— indeed, medieval people in general — tended to see themselves as sin-filled worms on the edge of a precipice leading directly to hell.

The preoccupation with the body and sin that was so much a part of the reform movements of the eleventh century, and the idea that one might starve oneself into the Kingdom of Heaven, was not far from the thought of the early Cistercian fathers. "If you want to enter Clairvaux," said its abbot, the charismatic (future saint) Bernard, to the postulants who entered there, "only your soul can come in; leave your body at the door."

There was an antidote to this preoccupation with one's sinful self — namely, charity, a virtue that was central to the Cistercian tradition. The document conceived by Stephen Harding as a type of constitution for the new order and an embodiment of its principles was not called the *Charter of Poverty* but the *Charter of Charity*.[11] Charity involves both God and one's neighbor, and the Cistercian writers never tired of reminding us that we cannot love God unless we also love our neighbor. Nowadays the word "charity" usually denotes alms-giving (which was also an obligation for all who followed the Benedictine *Rule*), but the *caritas* lauded by the Cistercians was much more. It was the perfect love described by Saint Paul in 1 Corinthians 13.

While these three elements — poverty, charity, and the *Rule* — remained the basis of Cistercian life, as the twelfth century advanced and thousands of men and women swarmed (the word used in medieval sources to describe the phenomenon) to join the abbeys, different aspects of Cistercian spirituality were developed by different writers. The best known is Bernard of Clairvaux, whose vision of monastic life was saturated with imagery of love and salvation. For Bernard, these were the essential concerns of a monk,

and one of the most important biblical texts for him – in fact, a widespread favorite among the Cistercians – was 1 John 4:19, "We love him, because he first loved us." The loving sacrifice of Christ inciting our love toward him is a consistent thread running through Bernard's writings. As a contemporary Cistercian abbot has recently written, love (*caritas*), for Bernard, is the key to understanding, the force behind expression, the common basis for the multiple realities of human life.[12]

Bernard is the best known and most prolific of Cistercian authors, but he was not the only author. Nor was he the most innovative. Different aspects were developed by other writers, many of whom have not received due recognition. Bernard's Christocentric theology, for example, must be distinguished from the Trinitarian spirituality of William of Saint-Thierry[13] with its emphasis on the importance of the Holy Spirit rather than on the person of Christ. And William's ideas were not the same as those of Isaac of Stella,[14] whose remarkable Platonic speculations are as difficult for us to appreciate as they must have been for his monks. Different again is Aelred,[15] abbot of Rievaulx in Yorkshire, with his emphasis on human friendship. Other Cistercian writers of the thirteenth, fourteenth, and later centuries – many virtually unknown in modern times – put forth still other ideas on monastic life. There was not just one Cistercian spirituality, but a mosaic of Cistercian spiritualities, and to extract only a few from the whole is to miss its glorious subtlety and remarkable diversity.

✻ ✻ ✻

What we have said thus far allows us to establish a theological basis for discussion of the more earthly side of Cistercian life. It is essential to remember that this life was lived largely in silence. The Prologue to the *Rule* quoted at the beginning of this essay, along with its development in chapter 6 — "the disciple's part is to be silent and to listen" — is crucial to an understanding of Cistercian life and architecture. When listening, rather than talking, makes up most of one's waking hours, a necessary shift occurs: in attention, in attitude, in orientation. This is not hard to verify; all we need to do is to watch how much of our attention in the course of a day is oriented toward conversation, and then consider how important that conversation really is. What if the energy and intelligence consumed by conversational activity were available for other things?

For example, *lectio divina*, or "sacred reading," is an important daily aspect of Cistercian devotion. At the beginning of Lent, each monk and nun received a book to read in the course of the coming year. Every day, winter and summer, weekdays and Sundays, there was a designated time for sacred individual reading. A book a year may not seem much to us, but again, it is not the quantity of reading that matters; it is the quality of the reading. Today we read, often as quickly as possible, for information. Monastic reading, on the other hand, was not so much for *information* as for *transformation*. One read in order to assimilate the words of God and of the Fathers, so that, eventually, one's own spirit was so imbued with their spirit that one began — slowly — to transform one's own, human, egocentric will into the "common will" (*voluntas communis*) of God.

When reading time was over, books – being precious and hand-copied – were locked in cupboards in the cloister book-room, and one moved on to the next task, in silence. The minutes spent walking from one place to another were used to continue the process that reading had begun, digesting the words, coming to a new understanding. The gradual assimilation continued whether one was tilling a field, preparing a meal, or doing any other chore. Silence provided the ambiance for both physical and mental work.

Community as well as individual reading was also part of the monastic day. Meals provided another occasion for the process of transformation, where the spirit was nourished along with the body. Far be it for monks to chatter idly at table, or even to discuss abbey business. Silence reigned in the refectory where they ate, allowing the voice of the week's reader – who was seated in a pulpit built high into the wall – to carry throughout this large room.[16] Another occasion for community reading was in the evening, just before Compline, the last office of the day. The reader read aloud to the assembled monks seated on benches in the cloister gallery; the texts were specially chosen to avoid violent subjects that could perturb sleep. In addition, of course, are the monastic offices – some longer, some shorter – that brought the community together eight times a day to chant the Psalms aloud.

✢ ✢ ✢

People sometimes wonder how monks earned their living. Once again the *Rule* of Saint Benedict (ch. 48) is the touchstone: "Idleness is the enemy of the soul. Therefore the brethren should be occupied at certain times in manual labor, and again at fixed hours in sacred reading. … And if the cir-

cumstances of the place or their poverty should require that they themselves do the work of gathering the harvest, let them not be discontented; for then are they truly monks when they live by the labor of their hands. . . ." In fact, the Cistercian grange (farm) system not only provided the abbey with its material sustenance, but played an important role in the development of the medieval rural economy.

A Cistercian abbey was required to be economically self-sustaining. Located in the countryside, often in valleys, each monastery owned and worked a series of granges. Each grange had barns, stables, housing, and a chapel, plus whatever other structures were needed for the work particular to that location, such as forges, mills, tileries, and fishponds. Large herds of cattle were maintained, crop rotation was practiced, salt was mined, cheese was made, iron ore was extracted and worked, and water power was harnessed, to name only a few of the most common agricultural and industrial activities. It was not unusual for an abbey to have a dozen or more granges, some a considerable distance away.

To maintain the rapid expansion of this system, the institution of lay brothers was adopted. Lay brothers were "lay religious," celibate men who took vows of poverty and obedience, were part of the life and spirituality of the abbey, and whose principal vocation lay in physical – rather than liturgical – work. Most of the week the lay brothers lived at the granges, returning to the abbey on Sundays and major feast days. This does not mean that the monks did no manual labor, for manual labor was an essential part of Cistercian reform. Monks worked in fields nearer the monastery, since they had to return to the church at regular intervals throughout the day to carry

out the divine office — the *opus Dei* (work of God) — whereas the lay brothers said shorter prayers at regular intervals wherever they were working. The celebrated miniatures from Cîteaux illustrating monks at work were not fanciful artistic speculation, but real representations of early twelfth-century agriculture as practiced by the Cistercians.

The Cistercian day, then, had three core elements: liturgy (prayer and praise), sacred reading, and manual labor. These activities alternated throughout the course of each day, the schedule varying according to the season (longer hours of manual labor in summer, longer hours of reading in winter), the day of the week (no manual labor on Sunday), and the calendar of liturgical seasons and feast days. Each element addresses one of the three aspects of human nature described by St. Paul: the body (labor), the mind (reading and meditation), and the spirit (liturgy). When practiced in alternation, the activities provide an admirable — and effective — balance of physical, psychological, and mental engagement.

<div align="center">✳ ✳ ✳</div>

Where one lives is an important part of one's psychological make-up. No monastery — and no monk or nun — could be entirely separate from the surrounding landscape, and in their response to that landscape we may discern some of the most important features of Cistercian spirituality.

The majority of Cistercian abbeys were located in valleys at a considerable distance from existing settlements, but it would be wrong to think of a Cistercian monastery as being entirely isolated. Sometimes villages were moved in order to create the separation from the world necessary for

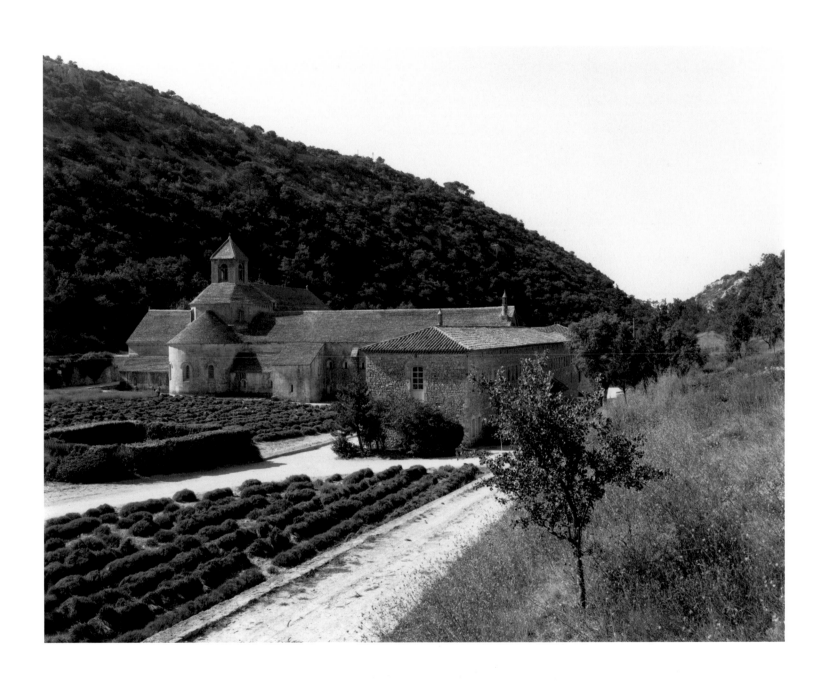

3. SÉNANQUE, 1986

monastic life; in other cases forests were cleared to provide enough new land; in still others, existing hermitages were converted into monasteries.

Living in a valley means, among other things, that to see the landscape one must look upward. "I will lift up mine eyes to the hills, from whence cometh my help" (Psalm 121:1) is not an abstract concept for most Cistercians. This stands in sharp contrast to earlier Benedictine sites, which were atop hills or even mountains (Mont-Saint-Michel off the coast of Normandy is probably the best-known example). In some valley sites the sun, which skirts the southern horizon during the winter months, never touches the cloister garth; sunlight is visible, but not tangible. This humble location can serve to encourage the process of "interiorization" – of the inward quest for the nature and ground of one's own being – that Cistercian monastic life invites in other ways as well. Looking outward necessarily means looking upward into the landscape, with the eventual and inevitable return of the gaze to the valley, to the monastery, and, metaphorically, to one's self.

Life in such a landscape may seem like a glimpse of Paradise to those who are unaware that extensive water management during the initial construction, plus several centuries of adaptations and improvements, have in large measure tamed the wild hand of nature. Seasonal rains could be ferocious; rivers flood, life is threatened, water may subsequently dry up and hydraulic power disappear. No doubt many a monk, listening to the rain slashing at the church windows during the night office, shuddered at the reality of the roaring and troubled waters of Psalm 46.

Cistercians became expert hydraulic technicians out of necessity. Living in a valley is a potentially dangerous adventure, and careful evaluation of

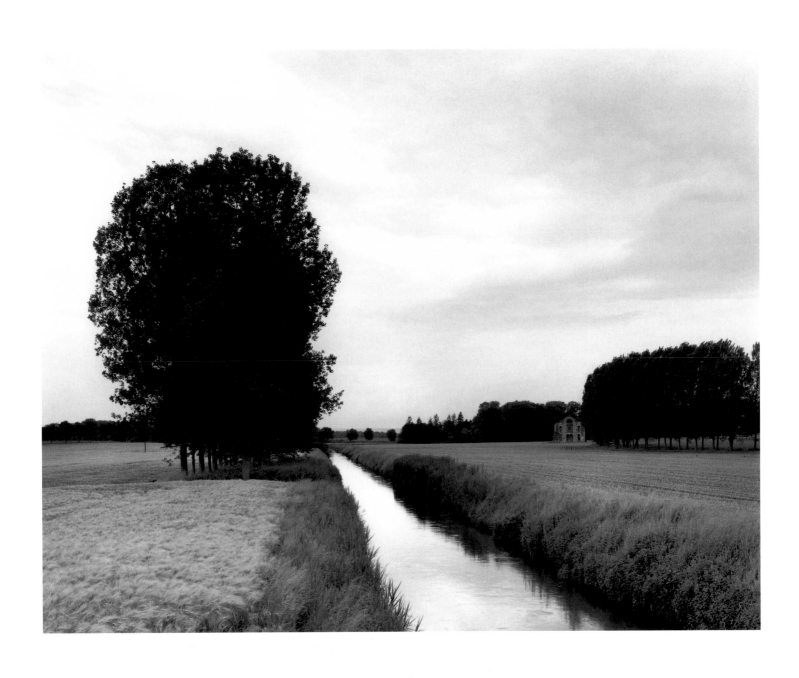

4. LANDSCAPE AT CÎTEAUX, 1995

the landscape was necessary before permanent buildings could be erected. Abbeys were sometimes built in the steepest part of the valley, or at a convergence of two valleys where water power offered the greatest potential. The river was often dammed to create a mill-stream, and sometimes the river-bed itself was moved to make a wider or more convenient building site. Archeological investigations have brought to light underground channels carefully built to allow evacuation of waste from latrines, kitchens, refectories, infirmaries, and other buildings. Some valleys were dredged down to bedrock and extensive drainage systems built so the site could withstand infrequent but potentially devastating floods.

Not only were rivers harnessed to make use of this abundant natural resource, but exquisite fountains — sometimes still in use — were created for water that was piped in from local springs and filtered before reaching the cloister. This provided not only a source of fresh water within the abbey — for cooking, ink-making, infirmary needs, washing, blessing, sprinkling around the monastery and other ceremonies — but also the appeasing sound of continuously splashing water inside the cloister.

<div align="center">✵ ✵ ✵</div>

With this overview of the theological, spiritual, psychological, and practical basis for Cistercian life, what can we now say about the architecture? Benedict's *Rule* tells what was necessary for monastic life, but the *Rule* makes no mention of buildings. Cistercian abbeys were nevertheless made of stone and brick and wood and mortar, and the stone had to be quarried, clay fired, wood hewn, and mortar mixed. All of these activities required the

acquisition of materials as well as the necessary technical expertise, including not least the design of the buildings.

As the monastic day, following the Benedictine *Rule*, is defined by a schedule of prayer, manual labor, reading, meals, and rest, every building inside the abbey has a specific corresponding function. And as the community grew larger or smaller over the ensuing decades and centuries, the rooms or buildings were altered to fit the changing circumstances. For the twelfth and thirteenth centuries, however, the function of each specific area is generally predictable, even if some details are lost. The fact that Cistercian life has continued unbroken since 1098 (a few abbeys — although none in France — have survived within the same walls) means that monastic life today can help interpret elements of buildings that are not obvious to a visitor.

Just as Cistercian life is based on the *Rule* of Saint Benedict and firmly fixed in the tradition of Benedictine monasticism, Cistercian architecture is firmly based on the traditional Benedictine plan. The cloister garth forms the center of the plan, giving access on all four sides to various interconnected rooms or buildings. The garth is usually square, if topography is favorable, and the whole abbey is laid out and built at the same time. Some cloisters are rectangular and a few are trapezoidal, reflecting the irregularity of the site or the vagaries of construction, but this is imperceptible from inside the garth itself. When the valley was so narrow that the abbey had to accommodate the slope of the land, as at le Thoronet, the irregularity has been absorbed so gracefully that this "imperfection" actually appears as an integral part of the design.

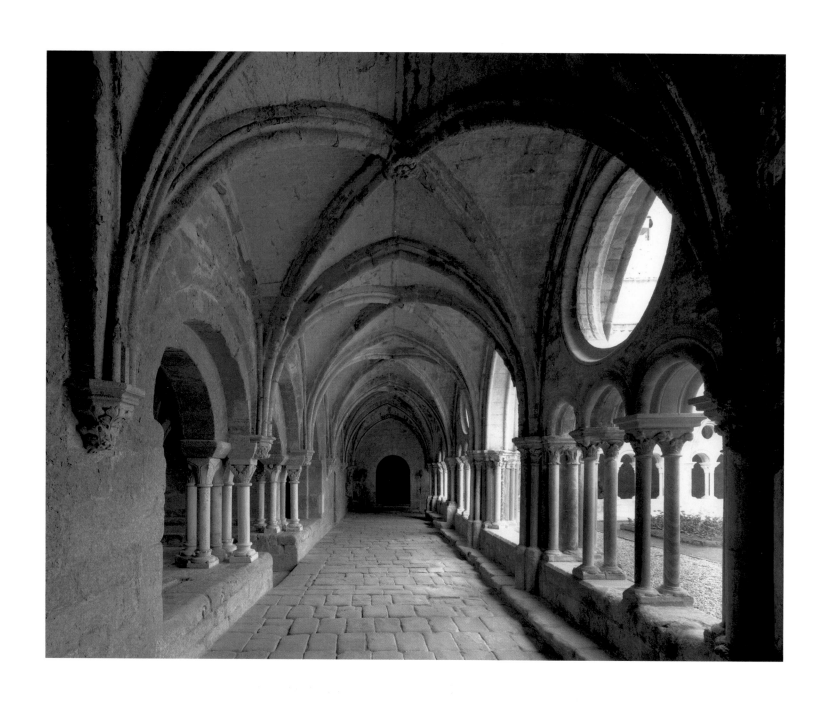

5. EAST GALLERY OF THE CLOISTER, FONTFROIDE, 1995

The four sides of the cloister are flanked with vaulted galleries that link the buildings and provide sheltered access from one room to another. As archeological traces indicate, they were more than simple walkways. Monks did their individual reading on benches along the walls; the community was read to there each evening before retiring. The galleries were used for processions on certain feast days, and the *mandatum* or weekly foot-washing ceremony (*pedilavium*) was held there, in imitation of Christ washing the feet of his disciples (John 13).

The four ranges or rows of buildings to which the galleries in turn give access are also designed according to function. The church is built on the highest ground to the north or south side of the cloister, depending on the lay of the land, with the apse and altar facing east. The *Rule* says, "Let the oratory be what it is called, a place of prayer; and let nothing else be done there or kept there," giving no suggestions for its size or shape. It is normally the largest building inside the cloister compound, to which a monk or nun returns numerous times in the course of each day for monastic offices, the Eucharist, and personal prayer. It is the major architectural statement of a monastery, and a wide range of church designs may be found in Cistercian abbeys. Some churches have no direct light in the nave, others have windows on one level, still others are illuminated on two levels. The church may be covered with a pointed barrel vault, or groined vaults, or even ribbed vaults, for Cistercians did not hesitate to adopt the latest technology if it served their purposes; pragmatism was a primary consideration. What the churches do have in common is the absence of figurative sculpture or painting and the subtlety of the decor; they are

neutral spaces against which the task of transformation was slowly accomplished. A similar avoidance of color and narrative decoration may be found throughout the cloister buildings. Light, falling across moldings and recesses, walls and window embrasures, provides the animation, with only geometric or floral forms on capitals and white window glass making patterns on the floor.

The east range is attached to the transept of the church. The sacristy, which communicates with both church and cloister, is followed by the book room or book cupboards, then chapter room, parlor (or auditorium), monks' day-room, and stairs to the dormitory. The main activities concentrated in this range are mental: community meetings, announcements, some types of work, reading. Again, the size and shape of the rooms depended on the scale of the rest of the complex. The chapter room is one of the most important spaces in an abbey, a common room with community functions that set it apart. Here a novice is received into the community, the abbot elected, sermons delivered, important visitors received, business discussed, punishment meted; abbots are also buried in the chapter room, remaining near the community after death. As though to mark its exceptional nature, the chapter room is slightly more ornate than other buildings, being set apart, for example, with marble capitals or twisted columns.

The buildings on the side of the cloister opposite the church, sometimes called the refectory range, all involve water or fire; the activities concern the body — drinking, cooking, eating, washing, warming.

The refectory is one of the most beautiful buildings in a Cistercian abbey, spacious and light-filled. Here we find one of the few Cistercian

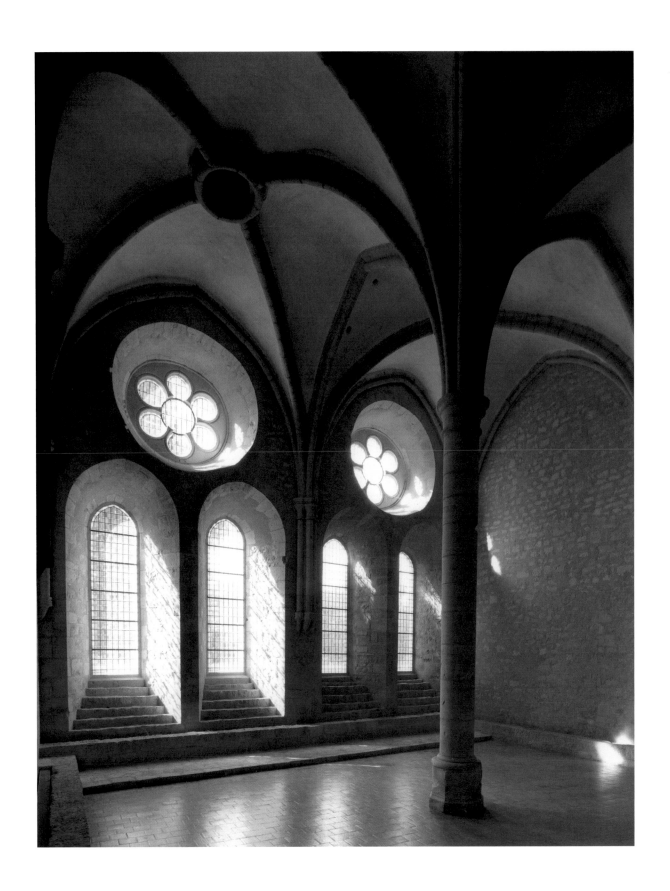

6. REFECTORY, NOIRLAC, 1990

variations on the traditional plan. In Benedictine abbeys, the refectory is built parallel to the church and occupies this entire range, and in some early Cistercian abbeys this disposition may also be found. Before long, however, Cistercians began to construct their refectories perpendicular to the cloister, projecting away from it. This modification had several advantages: it allowed an abbey to build as large, and as long, a refectory as was necessary for the size of the community; it also meant that large windows could be placed around three sides. Furthermore, other rooms could be placed on either side of the refectory, benefiting from direct access to the cloister gallery. Normally, the kitchens were on the west side and the warming room (calefactory) – the only heated room in the abbey – on the east side of the refectory.

The fountain was located opposite the refectory door, usually under a stone-vaulted pavilion that opened to the cloister garth through a series of elegant arches. The large monolithic fountain had multiple spigots around its periphery permitting thirty or more monks to wash before meals. Such efficiency was no doubt appreciated; food was not blessed until everyone was at table. Shaving and tonsuring were also carried out there seven times yearly, before the major feasts. The proximity of the abbey's main water supply to the fires of the warming room and kitchen was a practical advantage.

The fourth range, closing the west side of the cloister, was the lay brothers' building. Most lay brothers lived at the granges during the week, but on Sundays and feast days they needed a place in the abbey to eat and sleep. Lay brothers could number well in the hundreds, especially in the

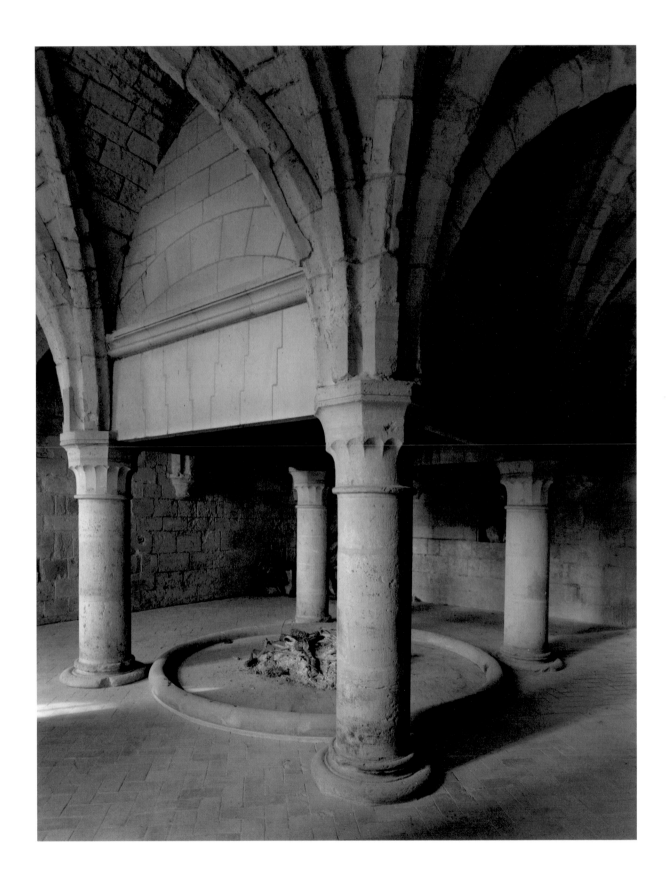

7. WARMING ROOM, LONGPONT, 1990

twelfth and thirteenth centuries, and their building is often of substantial size. Part of the ground floor served as their refectory and part as store-room, while the entire upper floor constituted the dormitory.

It is more difficult to discern the precise function of buildings located beyond the immediate area of the cloister since circulation, geography, and necessity, rather than a general plan, dictated placement. The monks' infirmary — often an immense light-filled and well-ventilated building — was usually located east of the church. It was connected to the cloister by means of a covered walkway, since ill but ambulatory monks were expect-ed to attend the offices. In later years, when monastic populations dwindled and buildings could not be repaired, the infirmary was sometimes trans-formed into a mini-monastery. Although its location is rarely known, a scriptorium would have been necessary for copying books, at least in ear-lier centuries before it became common to purchase them from profes-sional booksellers. As charity and hospitality are basic tenets of the *Rule*, the gatehouse, guesthouse, and guest infirmary were essential elements of a Cistercian monastery. They would have been near the main entrance, although each site must be studied carefully to determine the location of this entrance at the time of construction.

Mills, forges, tannery, bakery, dovecote, stables, and barns would all have been necessary, and they were built as water supply and other topo-graphical considerations warranted. Because of their utilitarian function, many survived wars and secularization and are sometimes still in use, although they have not always been identified as former monastic depend-encies. Still further away — sometimes dozens of miles — were the granges,

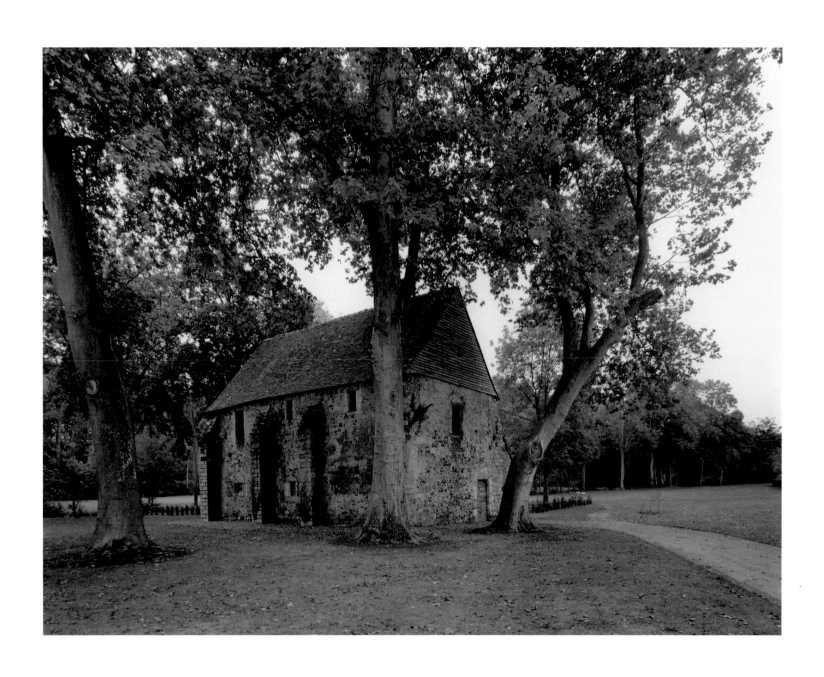

8. EARLY BUILDING, L'ÉPAU, 1990

providing the basis of the Cistercian economy. Some magnificent barns are still in use, and whether immense or modest, the quality of their construction is no less refined because of their humble purpose. Some granges are larger than churches, and equally well-built. When admiring a Cistercian barn, it is difficult not to be reminded of the Shaker tradition of the eighteenth- and nineteenth-century northeastern United States. The Shakers lived a similar spiritually based communal life, and their motto "hands to work, hearts to God" is a modern echo of the ancient Benedictine — and Cistercian — maxim *ora et labora* ("pray and work").

What, then, is the source of Cistercian architectural design? We have seen how the logic of the plan reflects St. Benedict's *Rule,* and how the Cistercians interpreted the Benedictine plan to make it function better for their purposes. A great deal has been written about the "uniformity" of Cistercian architecture, a view that tends to hinder acknowledgment — and appreciation — of the diversity to be found in the buildings. It is true that the *Charter of Charity* (*Carta caritatis prior*) says that Cistercian monks should live "by one charity, one *Rule,* and similar usages (*similibus moribus*)."[17] It is also true that some elements of design and placement recur in Cistercian buildings — especially of the twelfth and thirteenth centuries — although there are also many innovations and exceptions. But if there was an ideal "model" Cistercian abbey, its identity has not been preserved; no two identical buildings are to be found among the hundreds of extant examples.

It is useful to keep in mind that *similis* does not mean "identical," and that this phrase from the *Charter of Charity* referred more to an internal state of accord among Cistercians than to an outward manifestation such as a

building project. Obviously topography, weather, type of stone, size of community, and other practical factors would all contribute to the design of a building. Dozens — if not hundreds — of abbeys were simultaneously under construction in the twelfth century, from Ireland to Estonia, from Norway to Greece and Portugal. Recent research has begun taking into account both the diversity of Cistercian life and the flexibility necessary for successful management of an abbey. From the floor plan to the pleasing proportions of a nave to the seemingly perfect geometry of a capital, the buildings display a great deal of liberty both in design and in detail. Although there are general similarities — especially concerning the layout and relationship of one building to another, the voluntary simplicity, harmonious proportions, and absence of decor — there remain many exceptions and architectural mysteries.

The writings of Bernard of Clairvaux have often been interpreted as "recipes" for art and architecture, a view that also calls for re-examination. One of Bernard's most frequently cited works, the *Apologia* to William of Saint-Thierry, is not a treatise on art but rather on monastic spirituality, and the ideas it expresses must be seen against this background. The principle is simple: since the quest for oneself as the image of God — and for the God of whom we are the image — is an interior one, whatever may detract from the process of interiorization is to be avoided. We have already seen how a valley setting may be conducive to this process. In the *Apologia* we find Bernard railing against apes, lions, tigers, centaurs, harpies, hunters, soldiers, and other beasts that decorated the walls, capitals and books of Benedictine monasteries. Such plenteous variety, he tells us, leads us

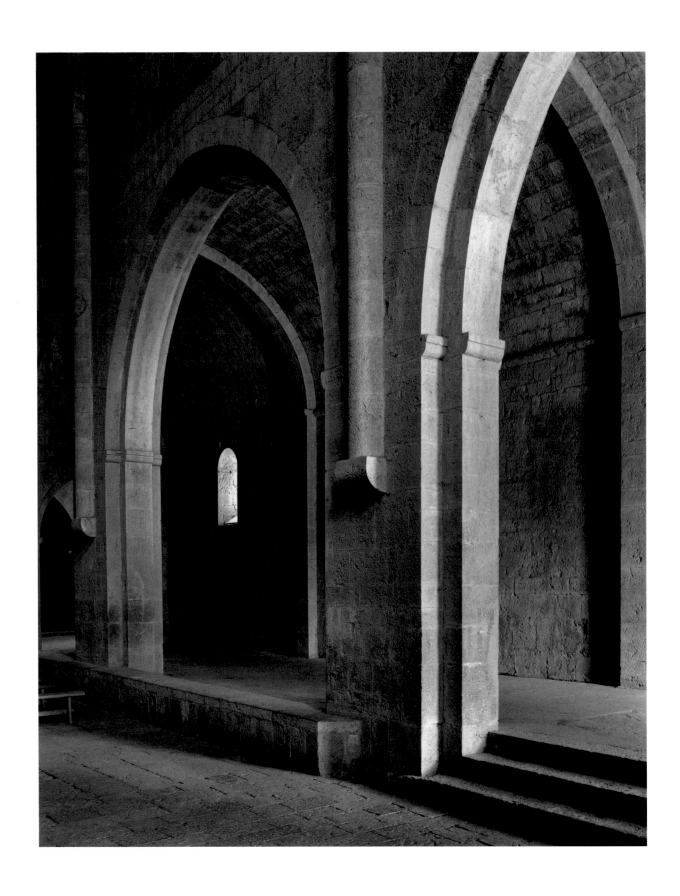

9. NAVE AND SOUTH AISLE, LE THORONET, 1986

to read the stone, not our books, and instead of meditating on the law of God, we are tempted to idle away the day marveling at wonderful images.

What Bernard objects to is not art for art's sake — the word "art" never appears in the *Apologia* — but to anything that detracts from the quest for the interior vision. Similar ideas are expressed by other twelfth-century Cistercians — Aelred of Rievaulx, for example, or Idung of Prüfening,[18] or Hélinand of Froidmont[19] — but the principle is logical and straightforward. Letters in manuscripts, therefore, "should be of one color and not decorated with painting"; glass "should be uncolored and without crosses and pictures"; and although walls might be covered with lime-wash and painted with false joints, the Cistercian General Chapter did not approve of the painting of figures.[20] They occur, certainly, though not before the thirteenth century, and those examples reflect changing times and tastes.

Minimal decoration in Cistercian churches and other abbey buildings was no more and no less than an effective practical aid to the process of interiorization. This process was facilitated by the location of the abbeys in valleys, and symbolized by the clearing and cultivating of waste land, and the careful attention to detail in unseen places as well as in visible ones. It is not accidental that the quality of the construction of sewers and cisterns is frequently as admirable as that of the churches.

There is yet more to be said, for the lime-washed walls and colorless windows of a Cistercian church are not only an absence of decoration, but a symbol of God himself. For what is God but — as Saint John says — light itself, and "in him there is no darkness at all" (1 John 1:5). He is the *lumen incircumscriptum* — the "limitless light" — of Gregory the Great[21] and Bernard

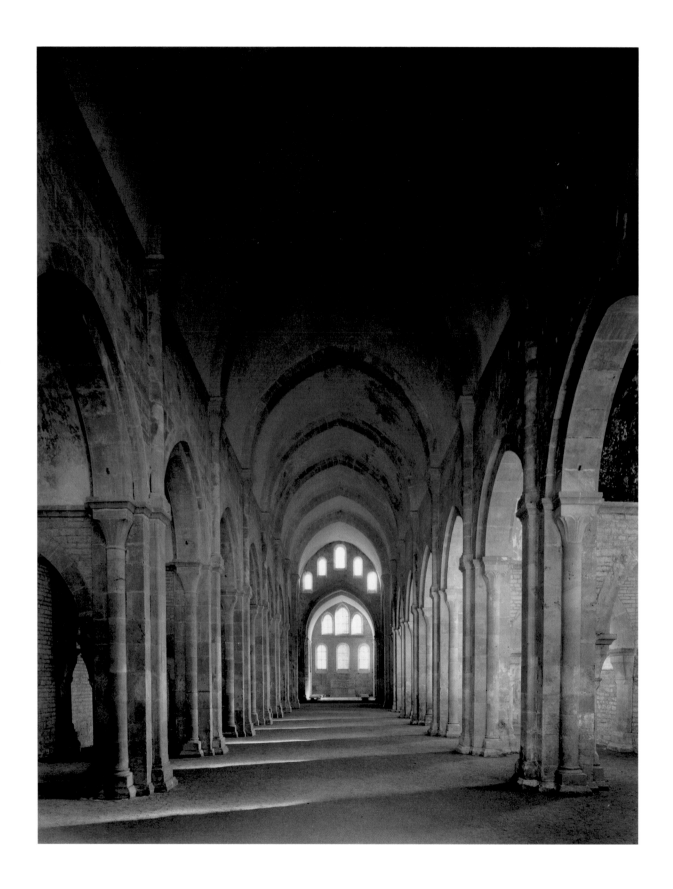

10. NAVE LOOKING EAST, FONTENAY, 1990

of Clairvaux, and the *lux nova* of pseudo-Dionysius and Abbot Suger of Saint-Denis.[22] The transition from darkness to light is one of the most basic yet profound symbols of spiritual progress. But God is not only light, he is also a "simple nature" (*simplex natura*) and wholly perfect. One sees in the light, simplicity, and perfection of Cistercian architecture both a symbol and a reflection of the light, the simplicity, and the perfection of God himself.

The simplicity of the architecture is everywhere apparent. The absence of narrative sculpture on capitals and over doorways only emphasizes the contrast of light and shadow, throwing the structural lines into even greater relief. Yet there is another very important element to Cistercian design: every effort was made to keep bright color out of Cistercian churches, an effect so ubiquitous that it can only have been deliberate and calculated.

The stained glass windows of the great cathedrals provide us with a reason for this exclusion. Color attracts the eye and excites the imagination, and while this may have been acceptable for a largely illiterate lay public, such distraction ran counter to the *raison d'être* of Cistercian life. Prayer and meditation are not helped by red and blue birds or purple-cloaked saints under bright green trees. The grisaille — translucent uncolored glass — in Cistercian church windows, shaped into intricate and lovely patterns, was a deliberate choice, entirely in keeping with the architecture. Color in the windows would drown out the careful play of light and shadow that characterizes the subtle balance for which Cistercian buildings are so admired, a subtle balance that was sought in monastic life itself. Grisaille in geometric

II. DETAIL OF A CLOISTER CAPITAL, FONTENAY, 1986

or floral patterns provides light that is neutral in its relative colorlessness, although in no way lacking in beauty. The same can be said for Cistercian floor tiles, which were limited in their range of rather dark colors but were laid in exquisite geometric patterns.

Were you to ask a Benedictine to show you the Deity, he might take you into a great cathedral and show you a splendid painting depicting Father, Son, and Holy Spirit, together with angels and archangels, principalities and powers, and all the company of heaven. If you were to ask a Cistercian to do the same thing, he might take you into the abbey church and show you three unadorned grisaille windows with light behind them, or simply an arch outlined in shadow. A Cistercian abbey – not just a Cistercian church – was designed to reflect not so much the glory of God (that had already been done at Cluny) as the nature of God, and to provide aspiring seekers with the most conducive environment for the realization of their divine potential. "For this alone were we created and do we live," wrote the twelfth-century Cistercian, William of Saint-Thierry, "to be like God, for we were created in his image."[23]

<p style="text-align:center">✵ ✵ ✵</p>

Cistercian architecture embodies two things. First, it reflects and symbolizes the nature of the God one seeks; and second, it provides an effective environment for the pursuit of this quest. It is not so much what the stones *are* but what they *do* that enables us to speak in this way, even though the very existence of the stones is a trace or vestige of the One who brought them into being. We must also remember that the nature of

the stones and their location was often determined by practical factors, of which water supply and political expediency were among the most important. This only confirms our hypothesis, for in approving a new site, in clearing the land, in building an abbey as perfectly as possible in places both visible and invisible, and in transforming a wilderness into a place of prayer and the presence of God, the Cistercians achieved with their hands what, within themselves, they sought to accomplish with their spirit. The heart of Cistercian architecture lies in its power to transform, and the abbey serves as a catalyst for our inward evolution toward an ever greater likeness to the image of God.

Terryl N. Kinder

CISTERCIAN ABBEYS
OF FRANCE

FONTENAY

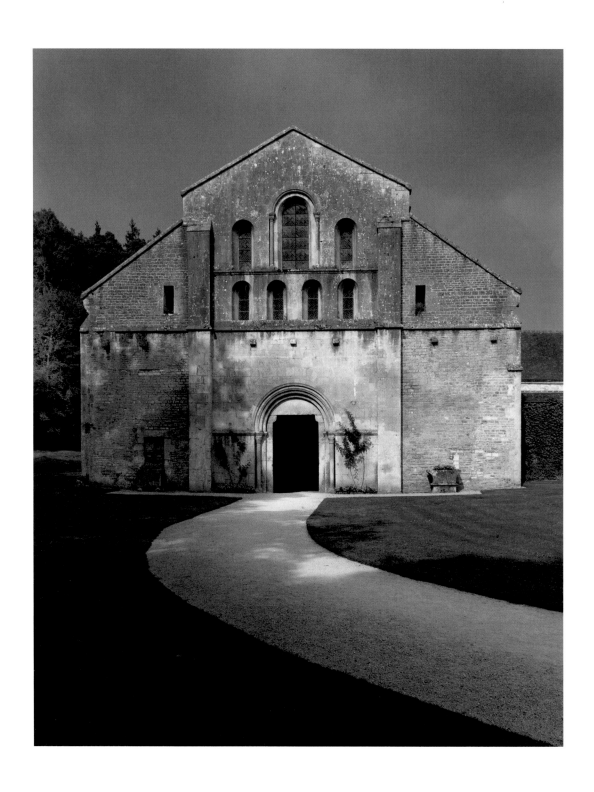

12. FAÇADE OF THE CHURCH, FONTENAY, 1986

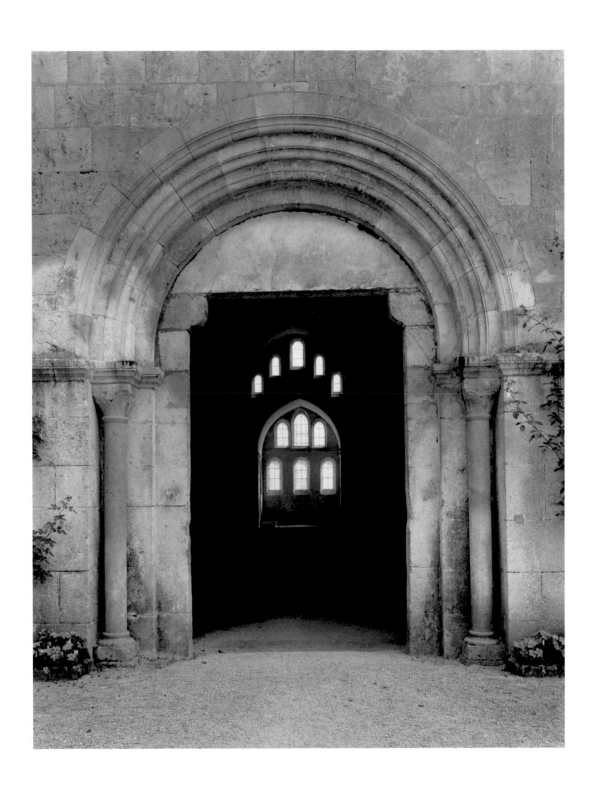

13. ENTRANCE PORTAL, FONTENAY, 1986

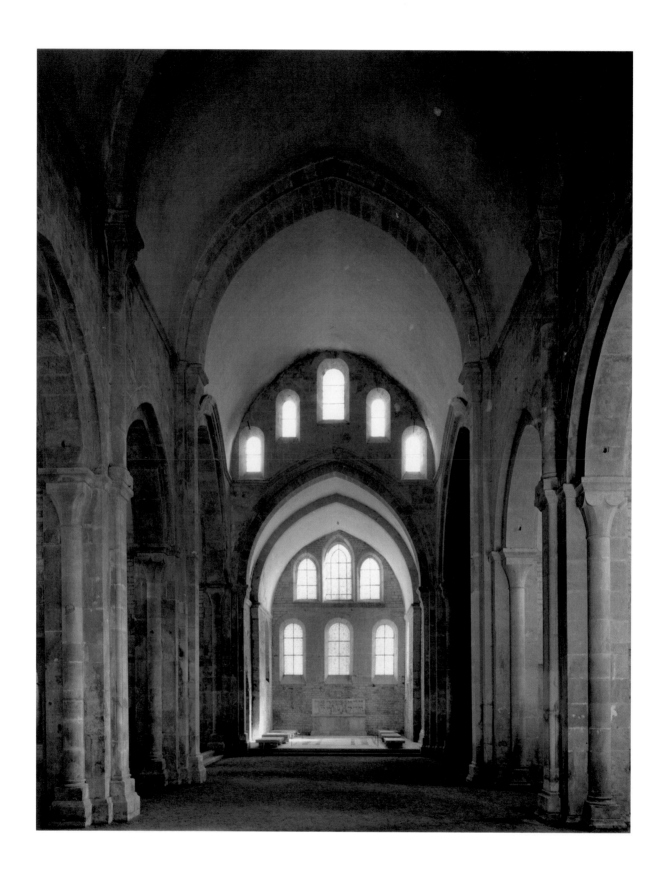

14. NAVE AND CHEVET, FONTENAY, 1990

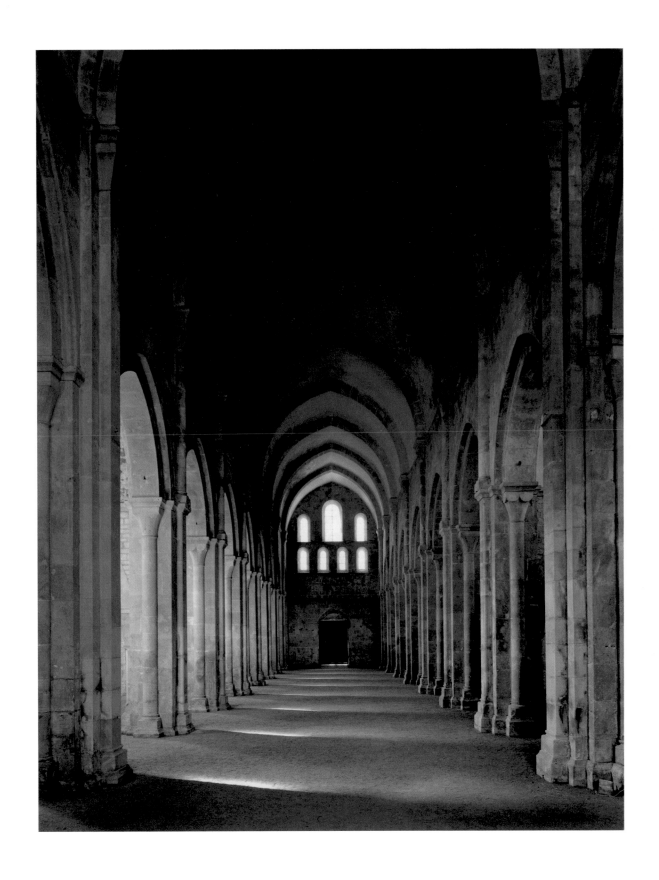

15. NAVE LOOKING WEST, FONTENAY, 1990

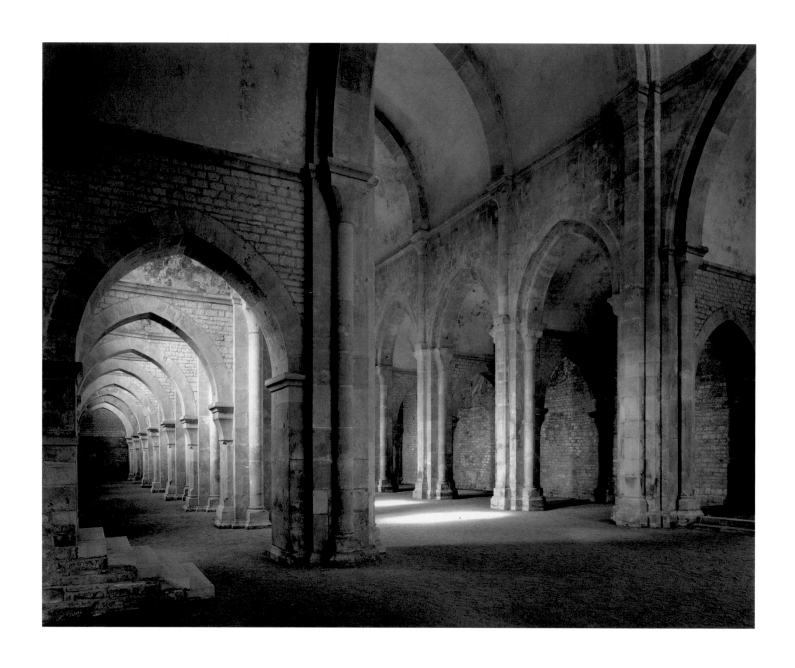

16. SOUTH AISLE AND NAVE LOOKING WEST, FONTENAY, 1990

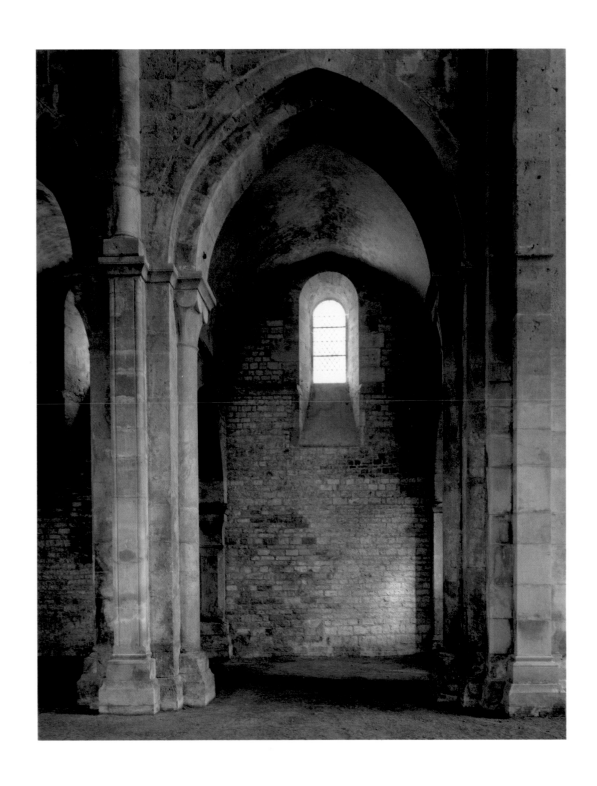

17. FIRST BAY OF THE NORTH AISLE, FONTENAY, 1986

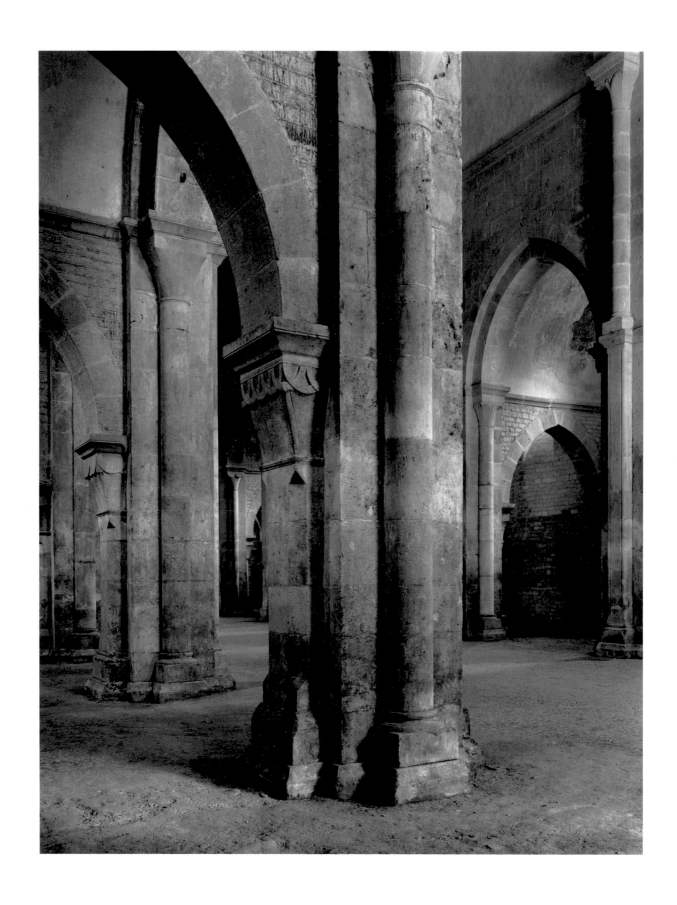

18. CAPITALS AND COLUMNS, NORTH AISLE AND NAVE, FONTENAY, 1986

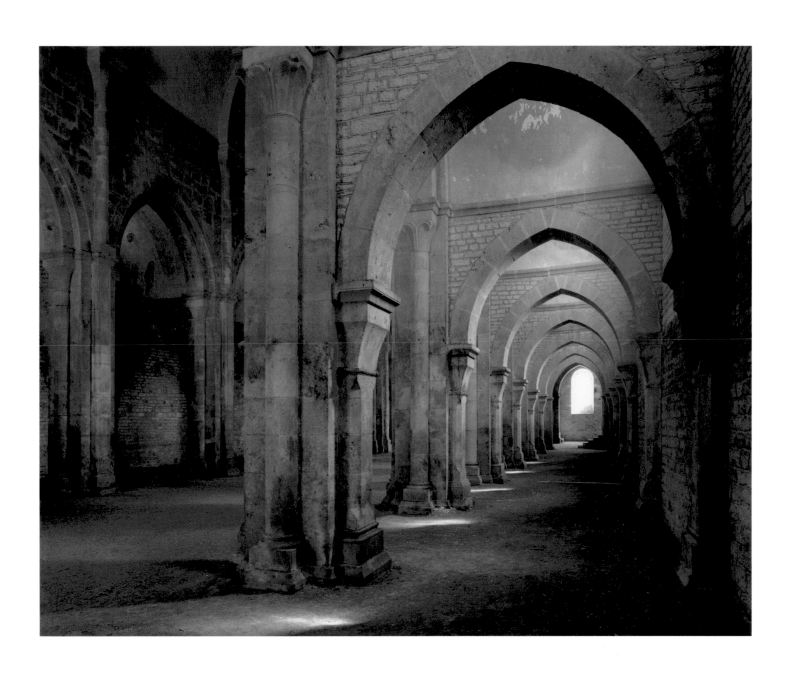

19. NAVE AND SOUTH AISLE LOOKING EAST, FONTENAY, 1986

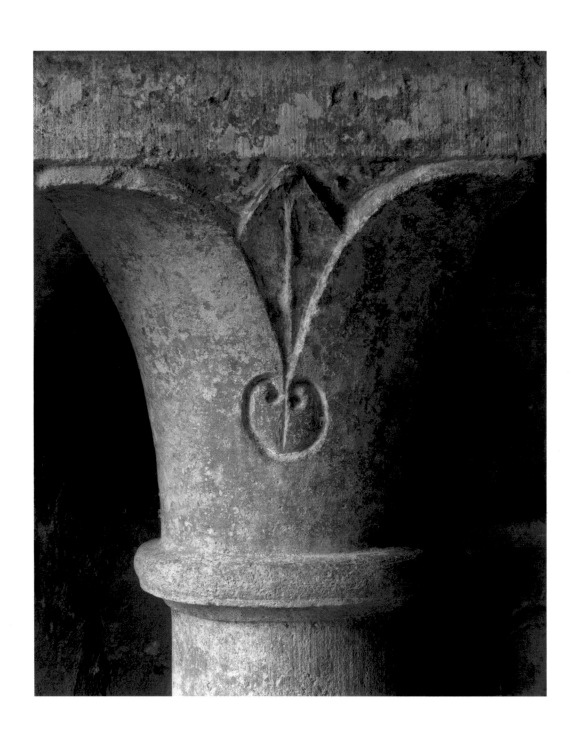

20. CAPITAL IN THE CLOISTER, FONTENAY, 1990

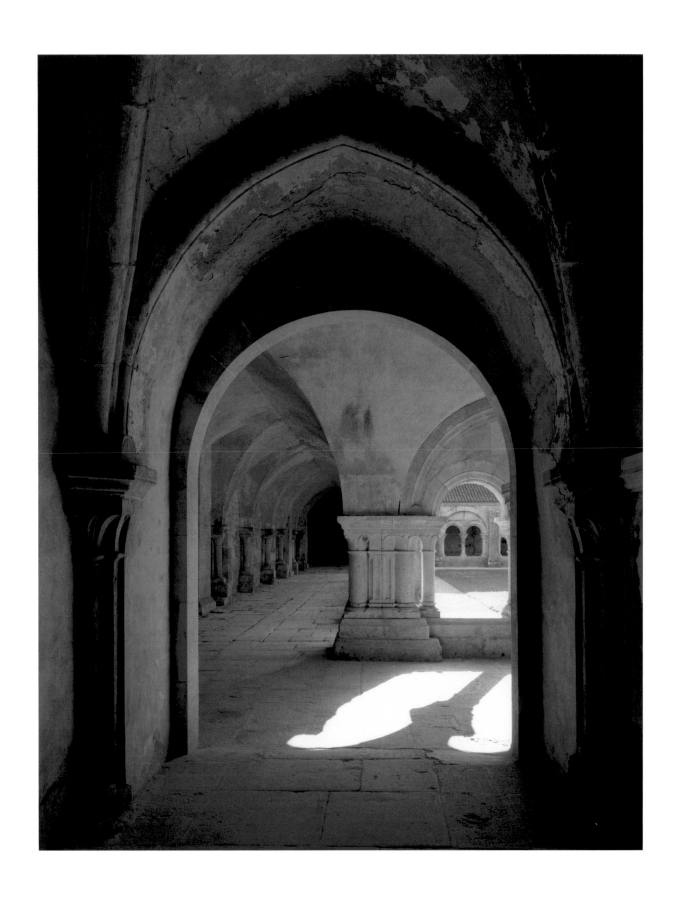

21. PASSAGE TO THE CLOISTER, FONTENAY, 1986

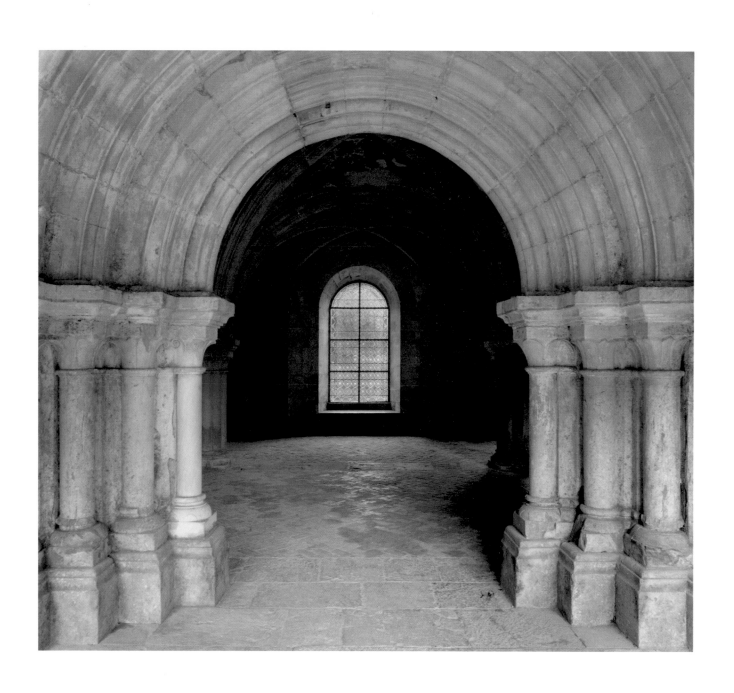

22. ENTRANCE TO THE CHAPTER ROOM, FONTENAY, 1990

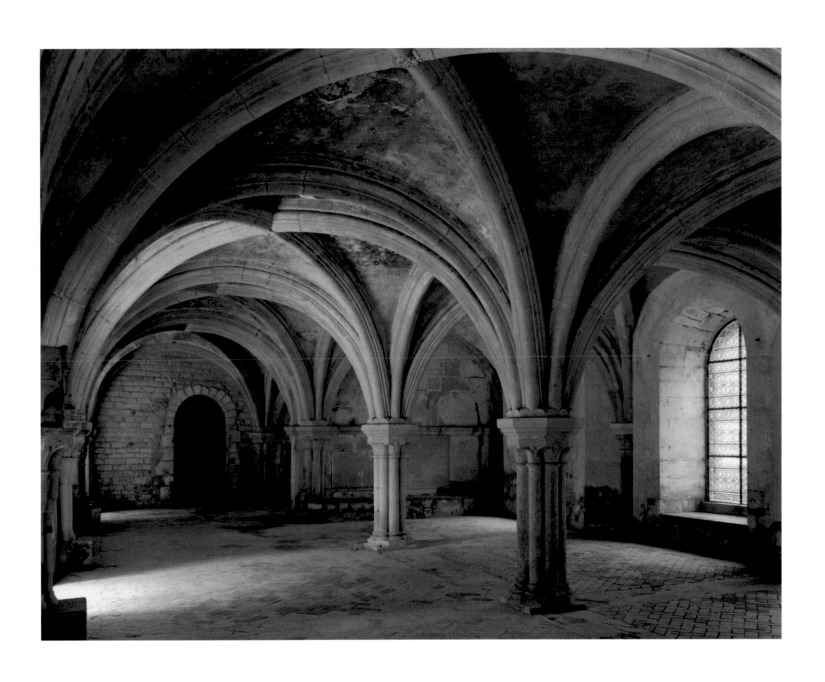

23. CHAPTER ROOM AND SACRISTY, FONTENAY, 1986

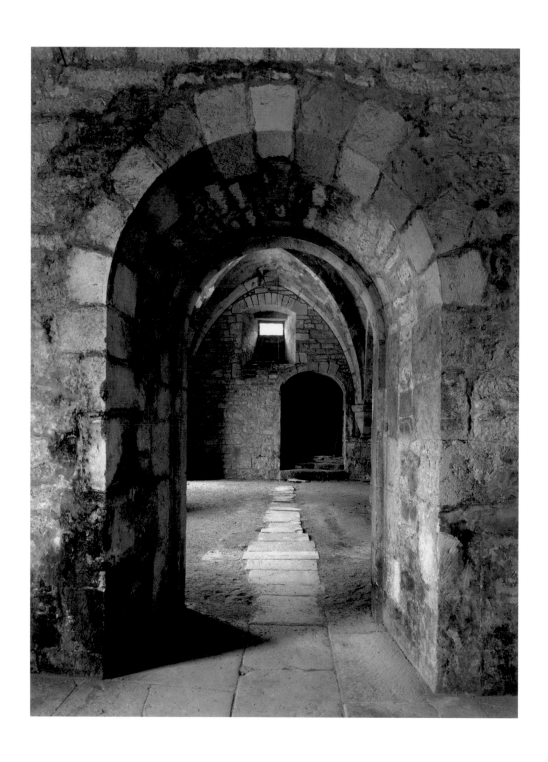

24. INTERIOR OF THE FORGE, FONTENAY, 1990

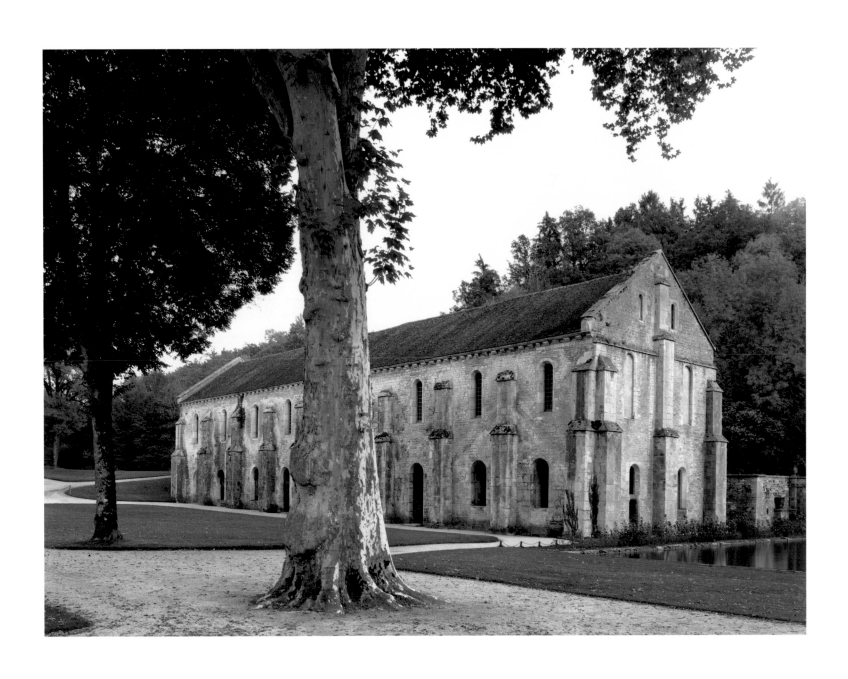

25. THE FORGE, FONTENAY, 1990

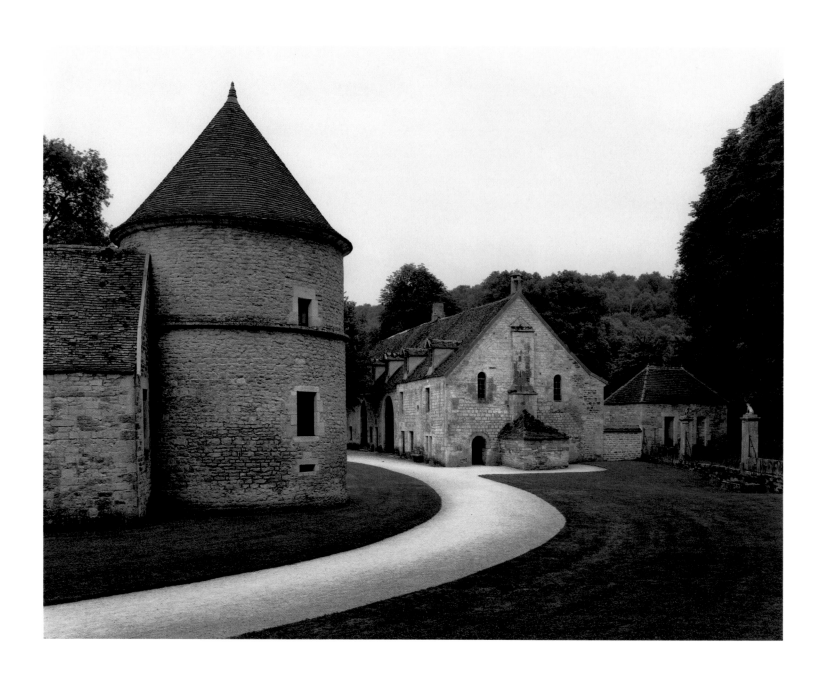

26. DOVECOTE AND BAKEHOUSE, FONTENAY, 1986

LE THORONET

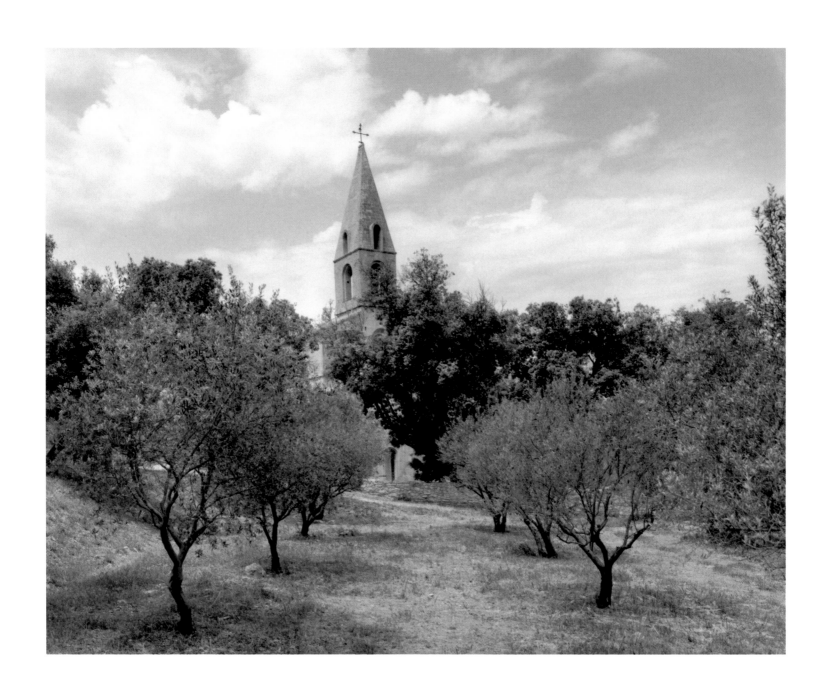

27. LE THORONET, 1995

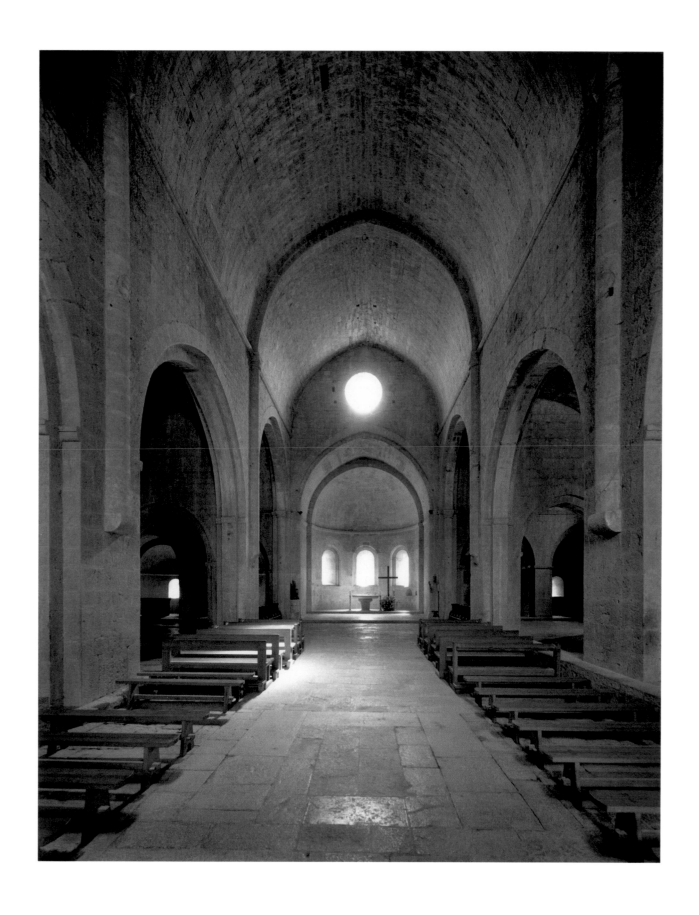

28. NAVE LOOKING EAST, LE THORONET, 1995

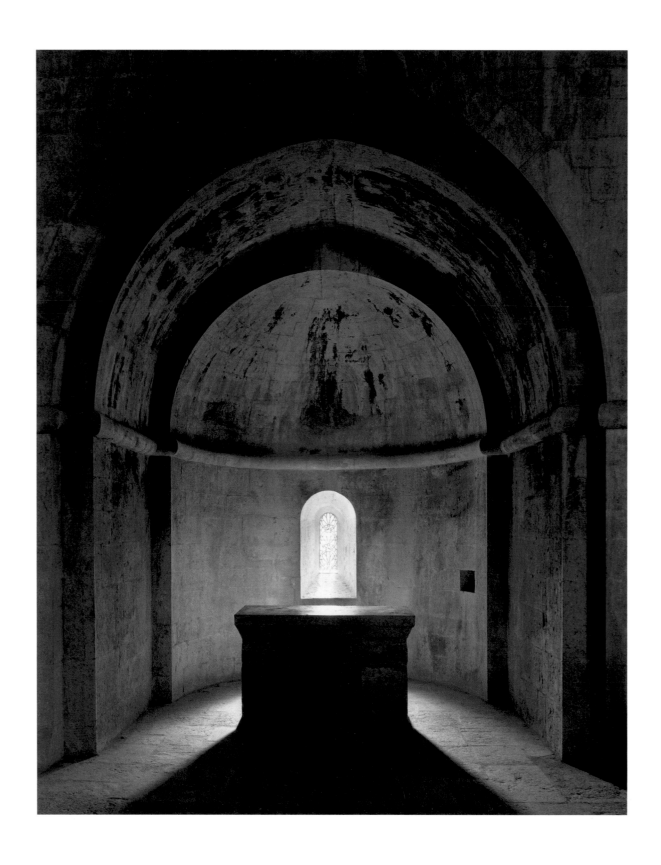

29. NORTH TRANSEPT CHAPEL, LE THORONET, 1995

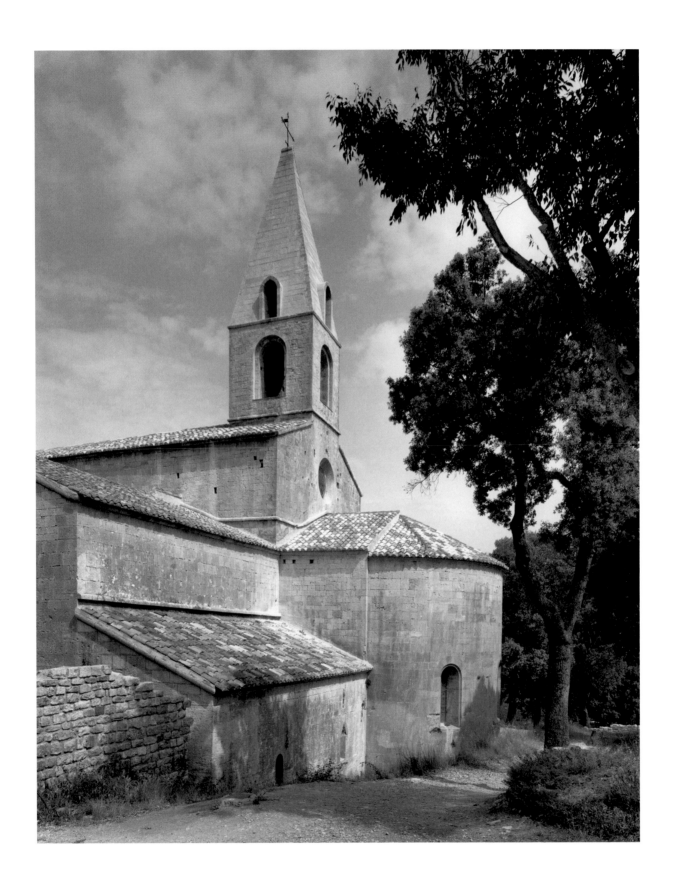

30. EASTERN END OF THE CHURCH, LE THORONET, 1989

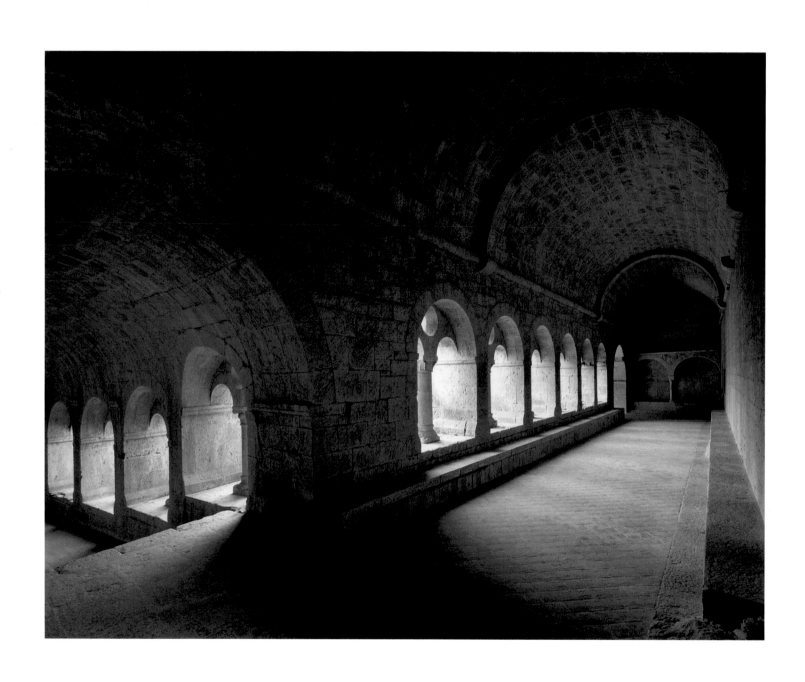

31. WEST AND SOUTH CLOISTER GALLERIES, LE THORONET, 1995

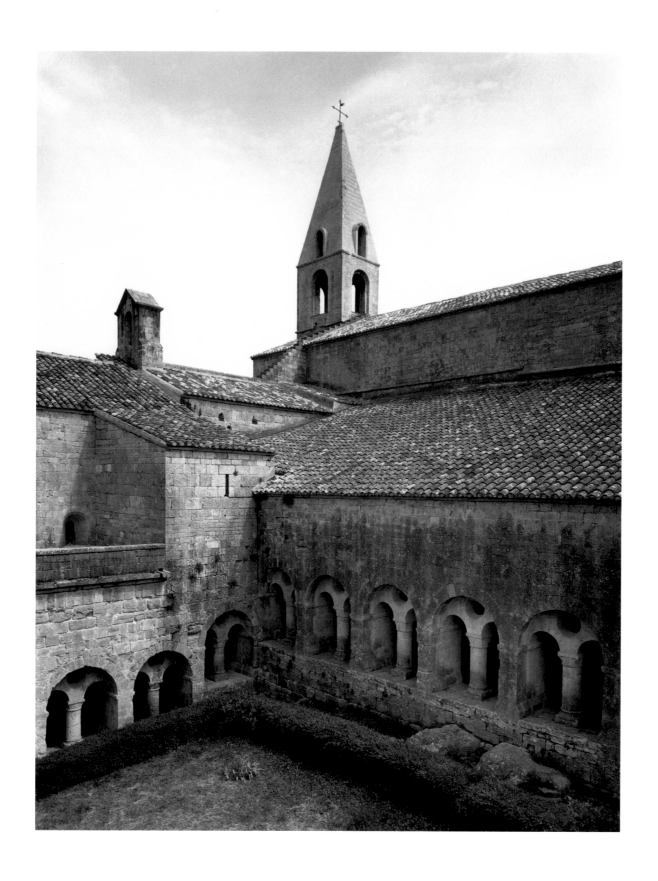

32. CLOISTER AND CHURCH, LE THORONET, 1989

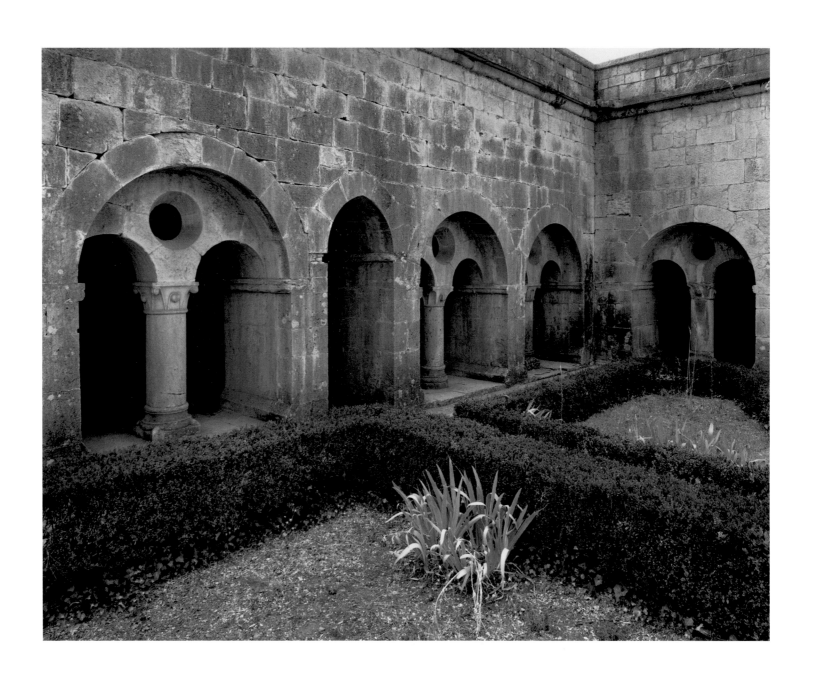

33. CLOISTER, LE THORONET, 1989

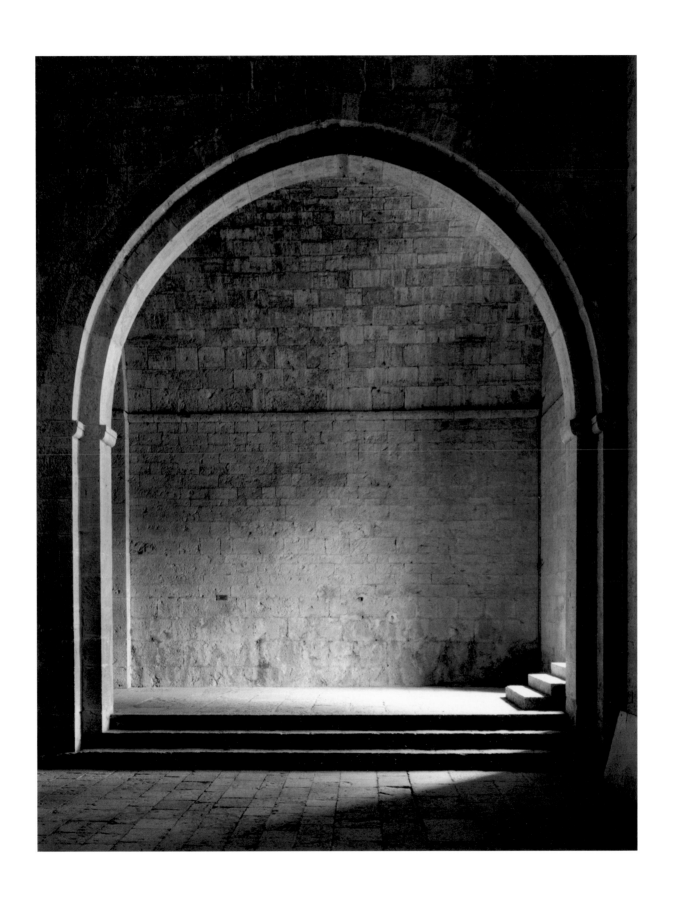

34. ENTRANCE TO THE SOUTH AISLE, LE THORONET, 1986

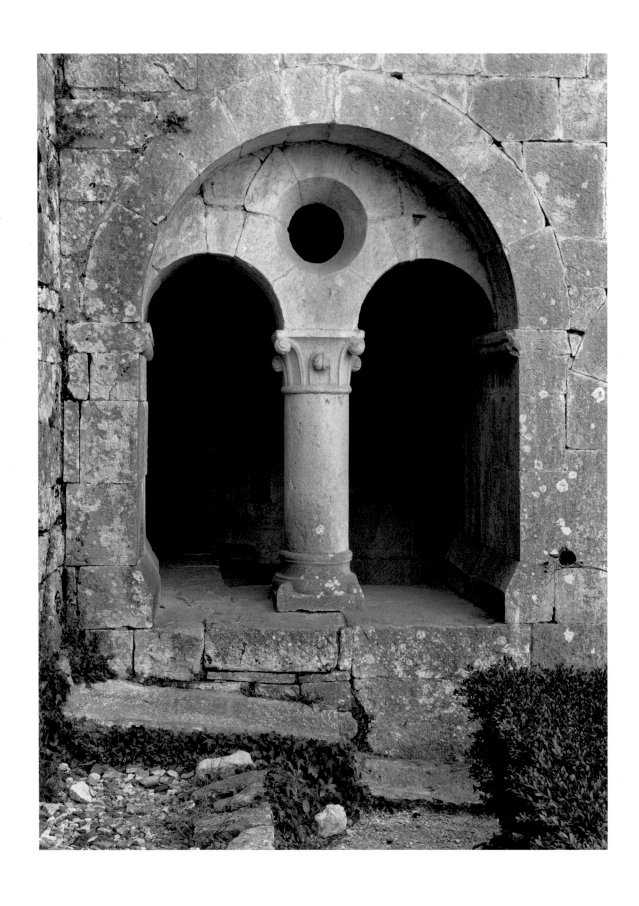

35. DETAIL OF THE CLOISTER, LE THORONET, 1985

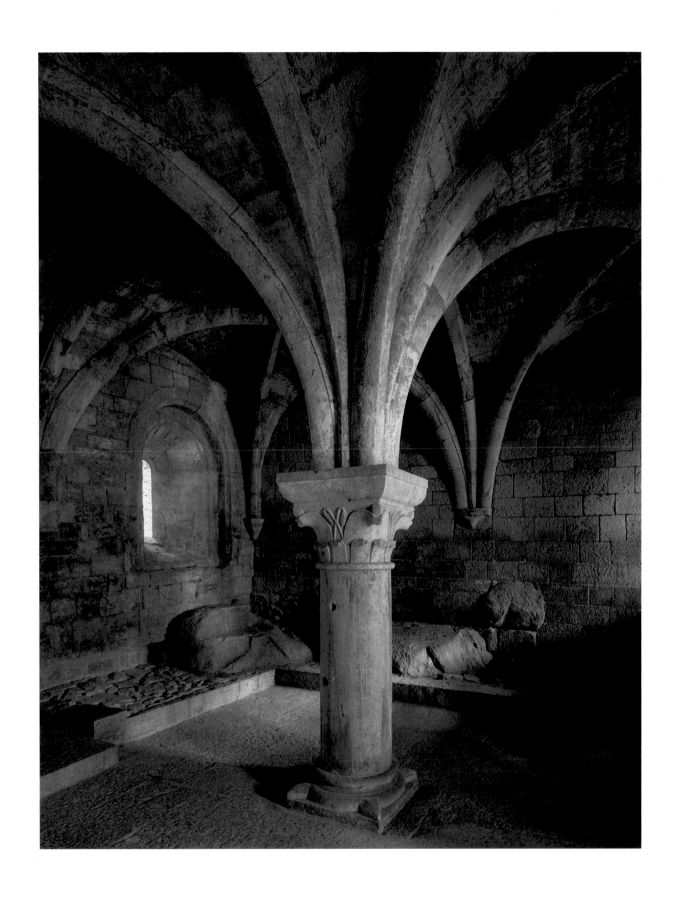

36. CHAPTER ROOM, LE THORONET, 1995

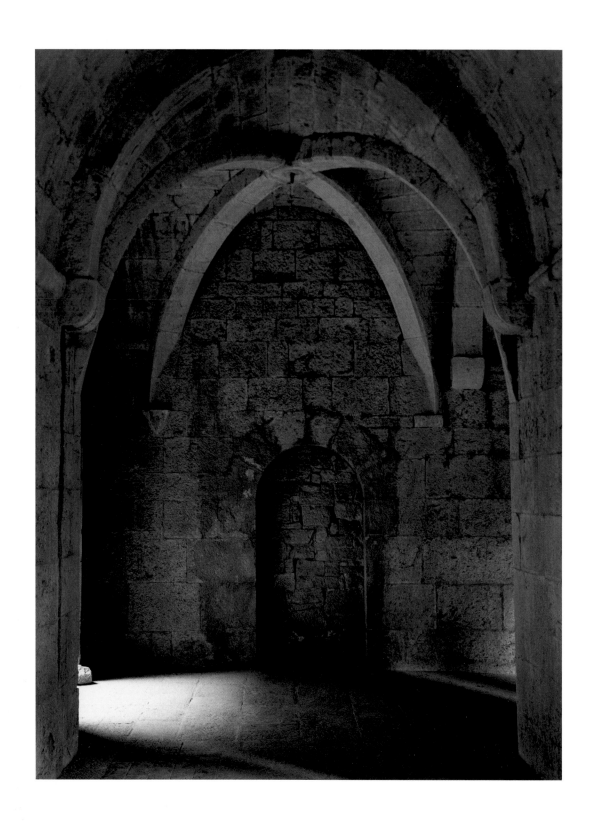

37. NORTHWEST CORNER OF CLOISTER GALLERIES, LE THORONET, 1989

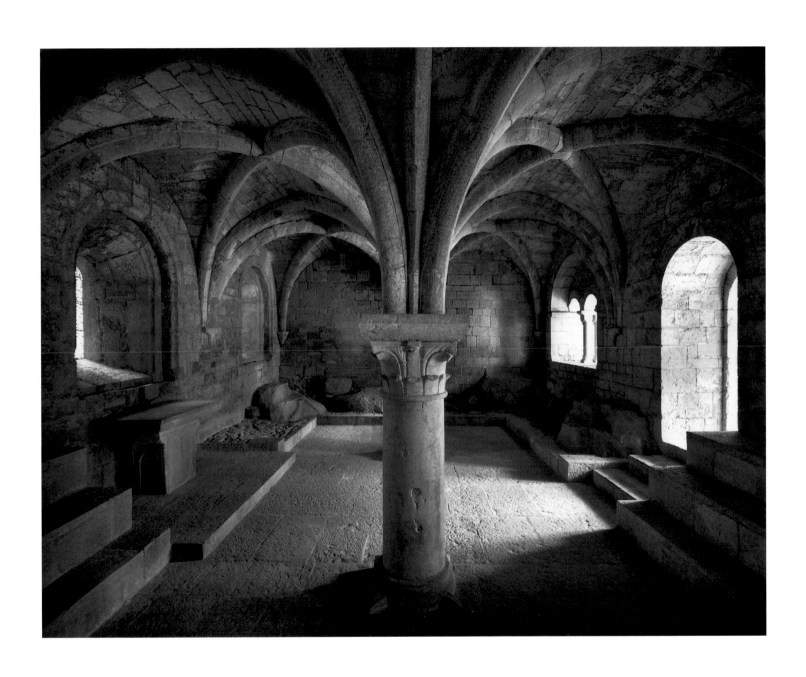

38. CHAPTER ROOM, LE THORONET, 1995

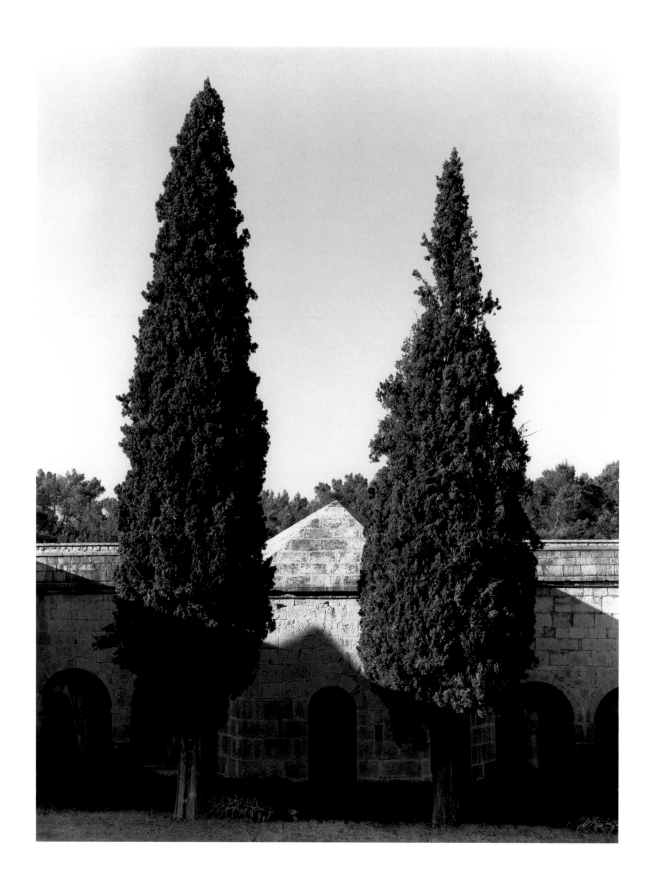

39. CLOISTER AND FOUNTAIN HOUSE, LE THORONET, 1985

SÉNANQUE

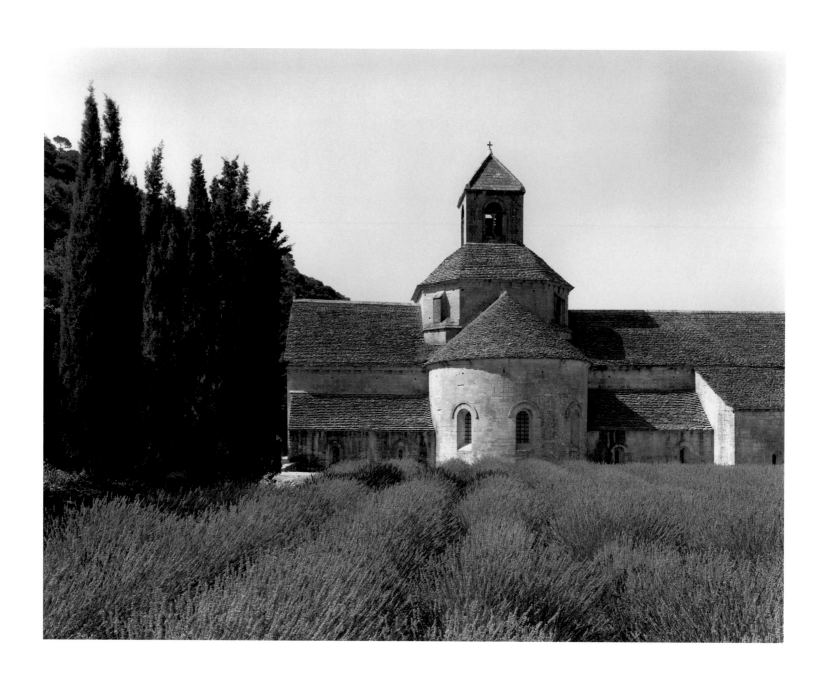

40. APSE OF THE CHURCH, SÉNANQUE, 1986

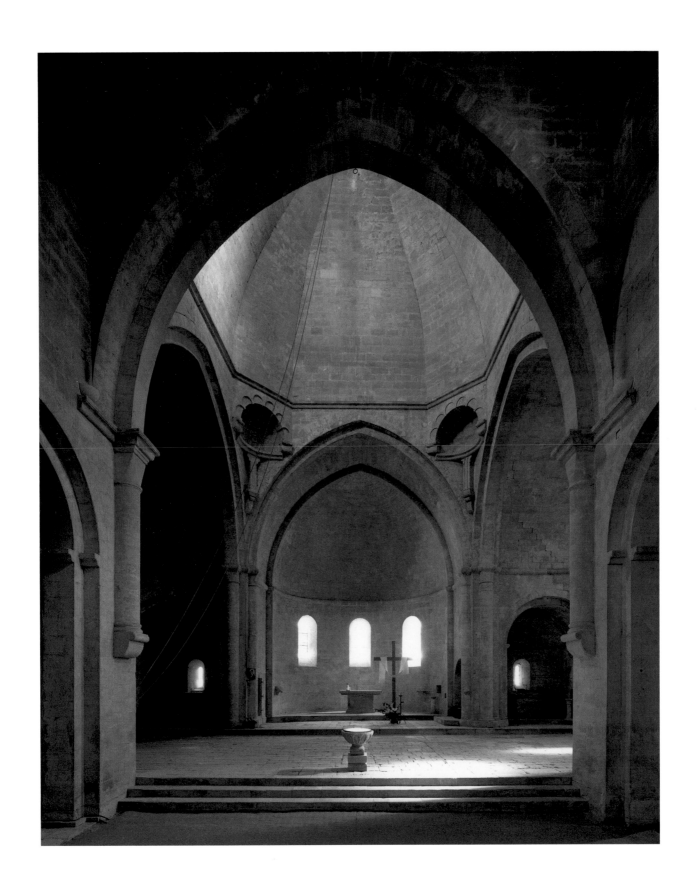

41. CROSSING AND CHEVET, SÉNANQUE, 1995

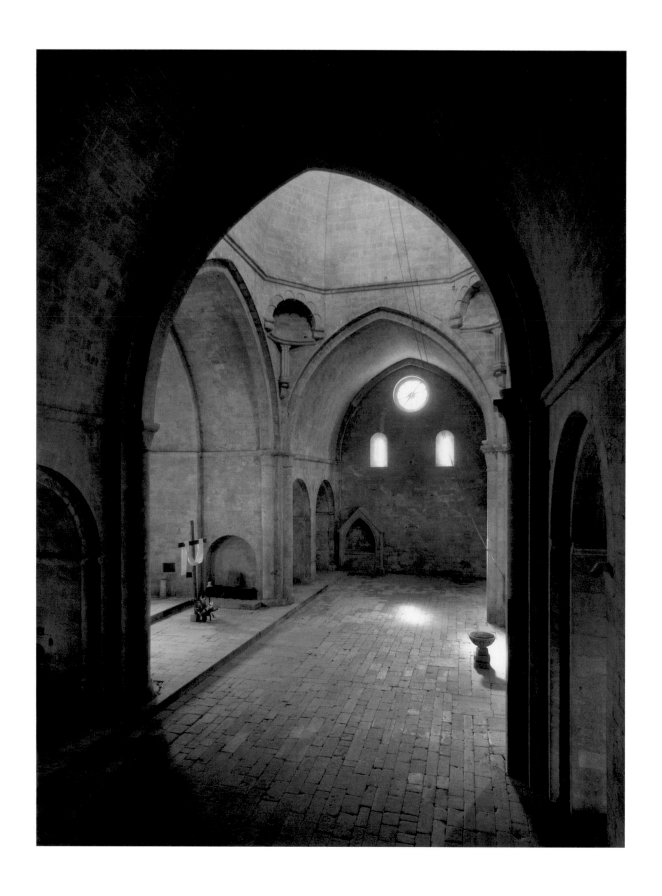

42. TRANSEPT CROSSING AND APSE FROM THE NIGHT STAIRS, SÉNANQUE, 1995

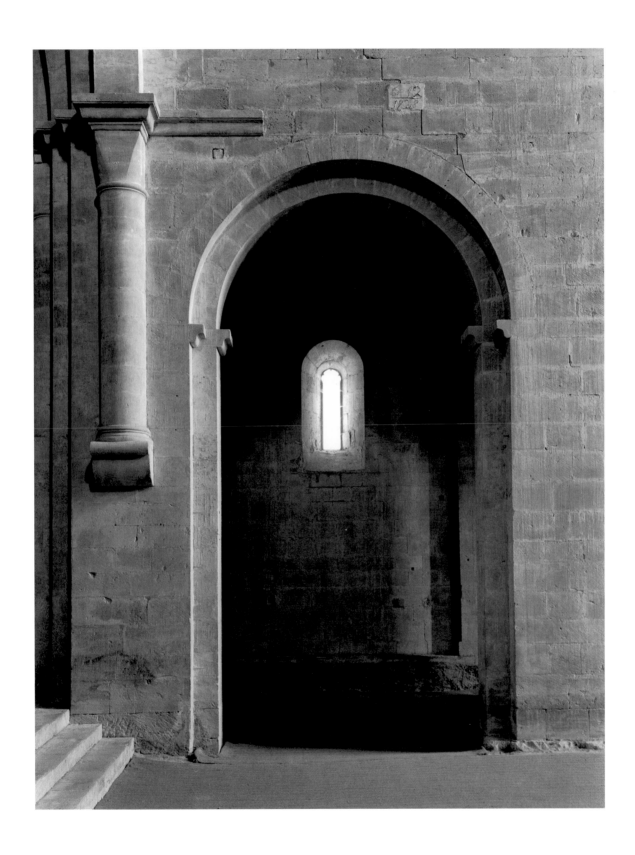

43. FIRST BAY OF THE AISLE, SÉNANQUE, 1986

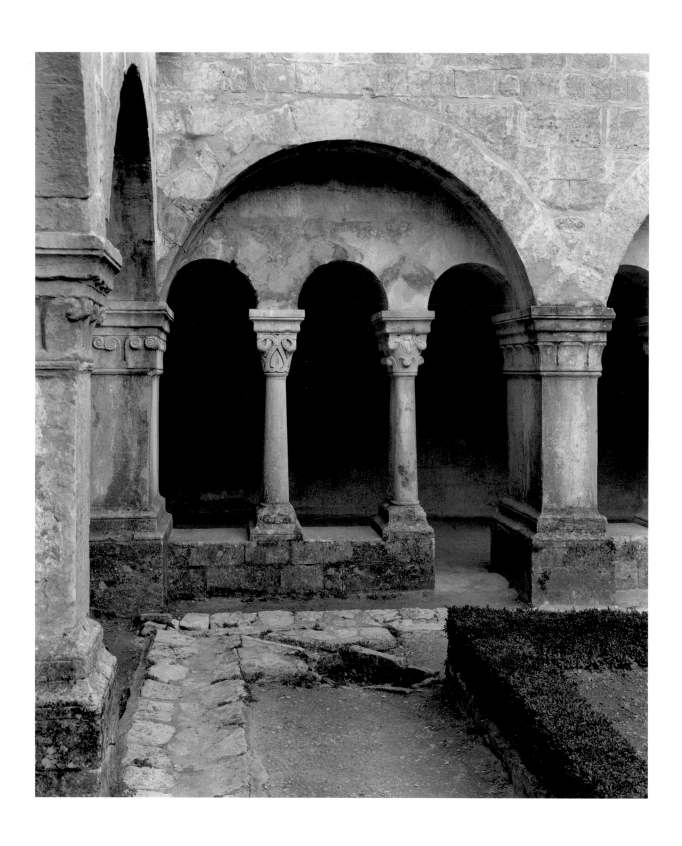

44. DETAIL OF THE CLOISTER, SÉNANQUE, 1986

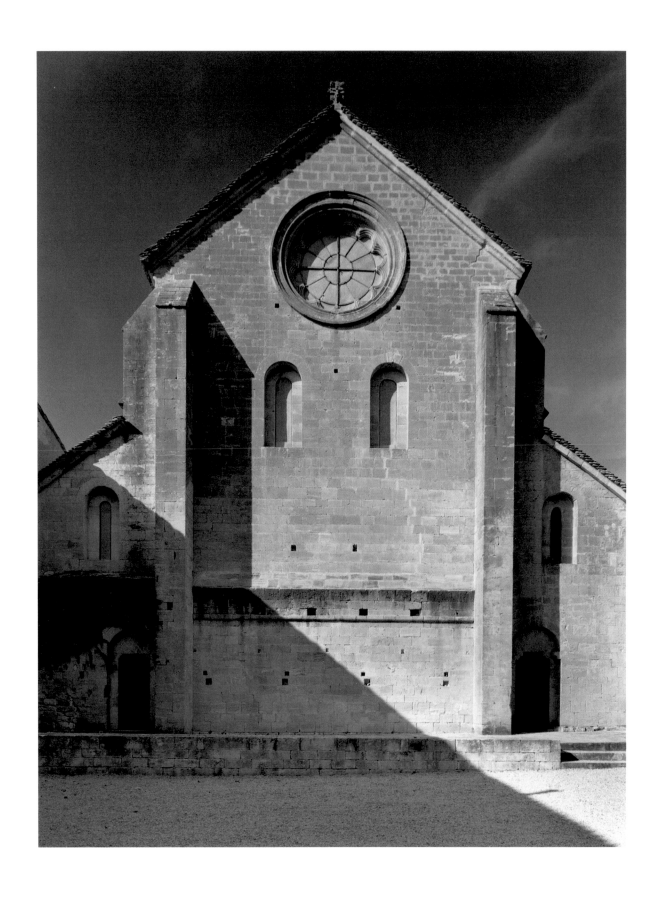

45. FAÇADE OF THE CHURCH, SÉNANQUE, 1986

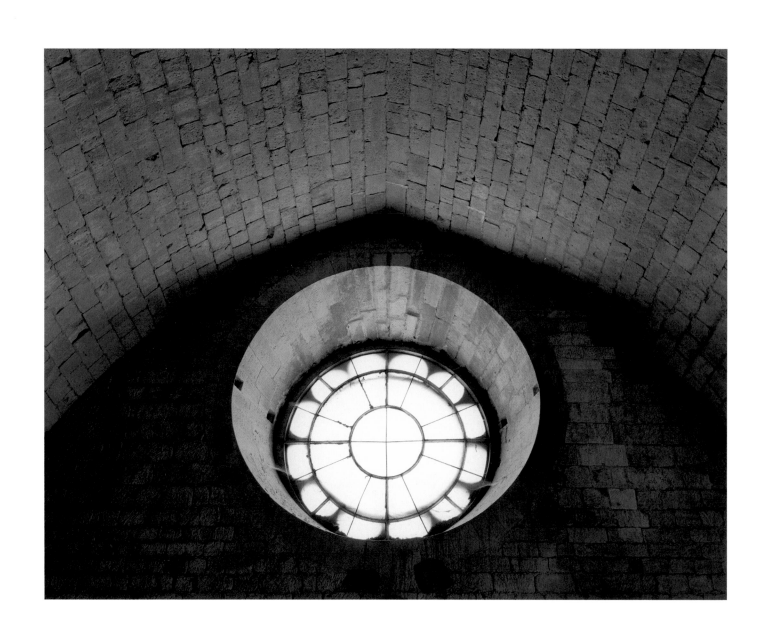

46. OCULUS IN THE MONKS' DORMITORY, SÉNANQUE, 1995

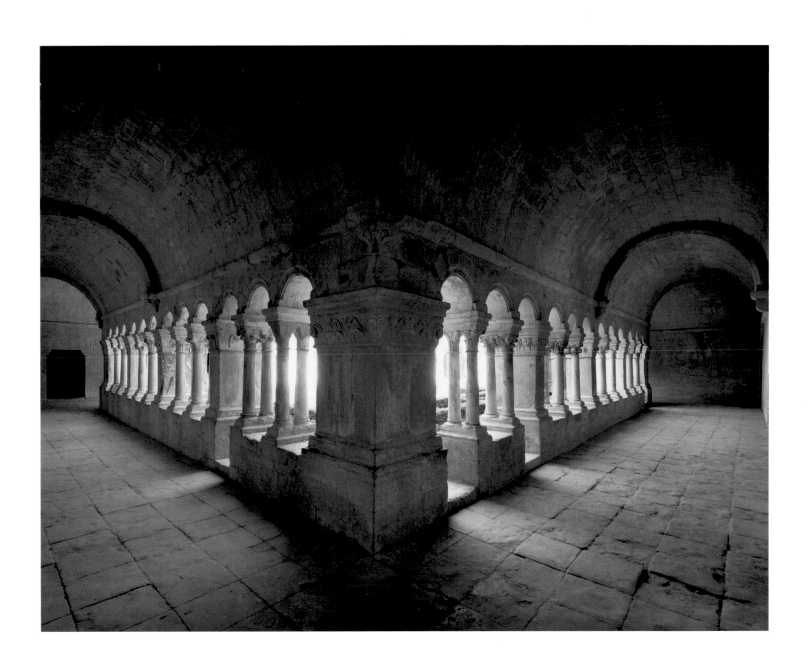

47. GALLERIES OF THE CLOISTER, SÉNANQUE, 1995

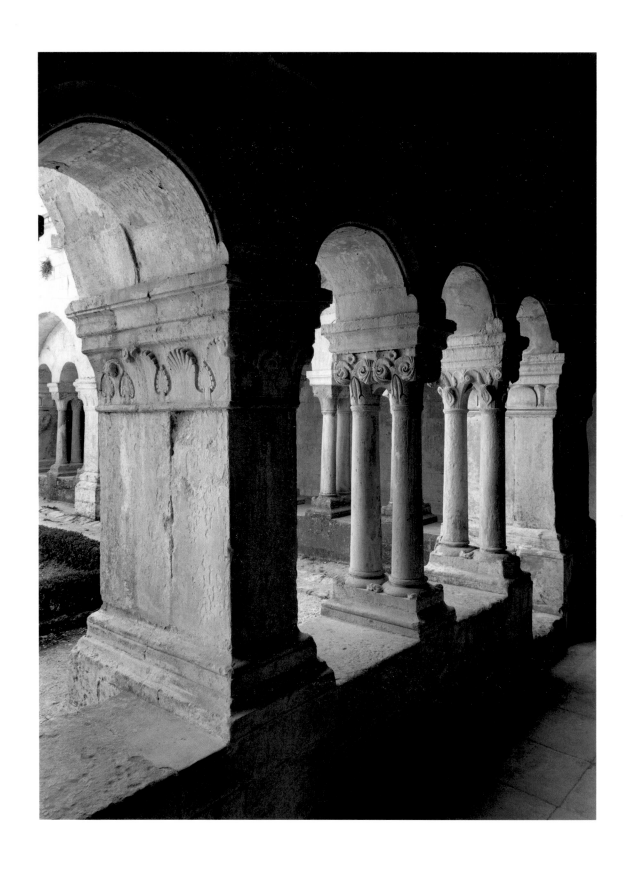

48. DETAIL OF THE CLOISTER, SÉNANQUE, 1986

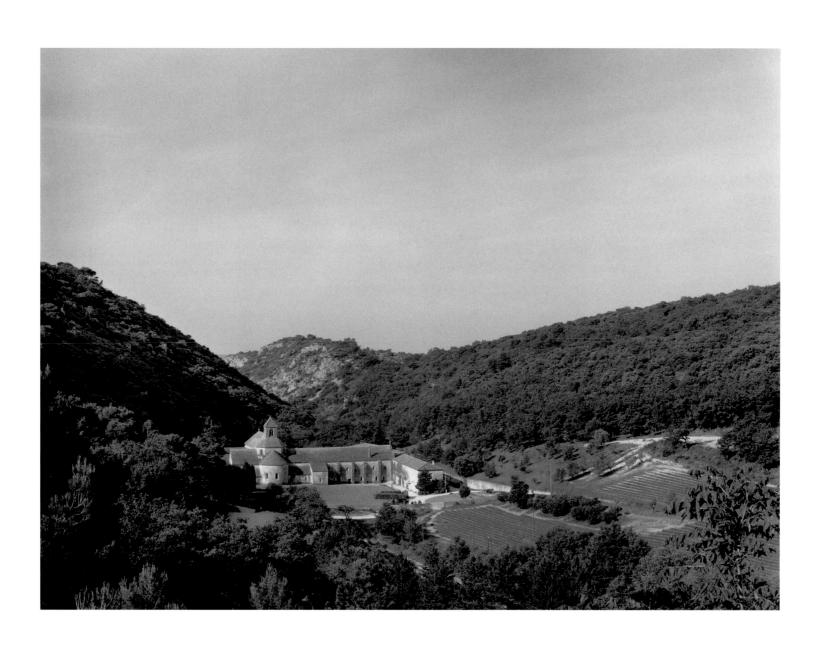

49. SÉNANQUE, 1995

50. MASON'S MARK, FAÇADE OF THE CHURCH, SÉNANQUE, 1995

SILVACANE

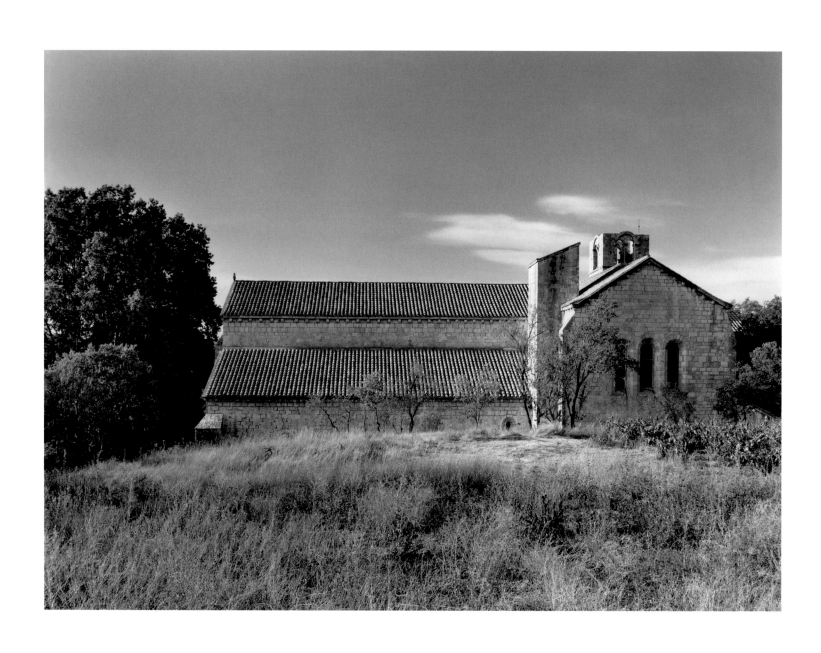

51. CHURCH FROM THE SOUTH, SILVACANE, 1986

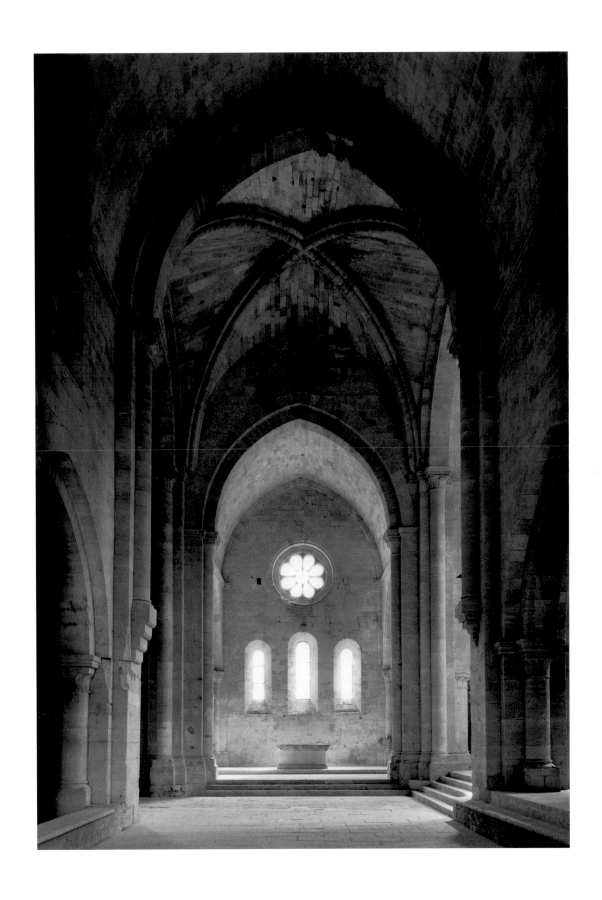

52. NAVE AND CHEVET LOOKING EAST, SILVACANE, 1986

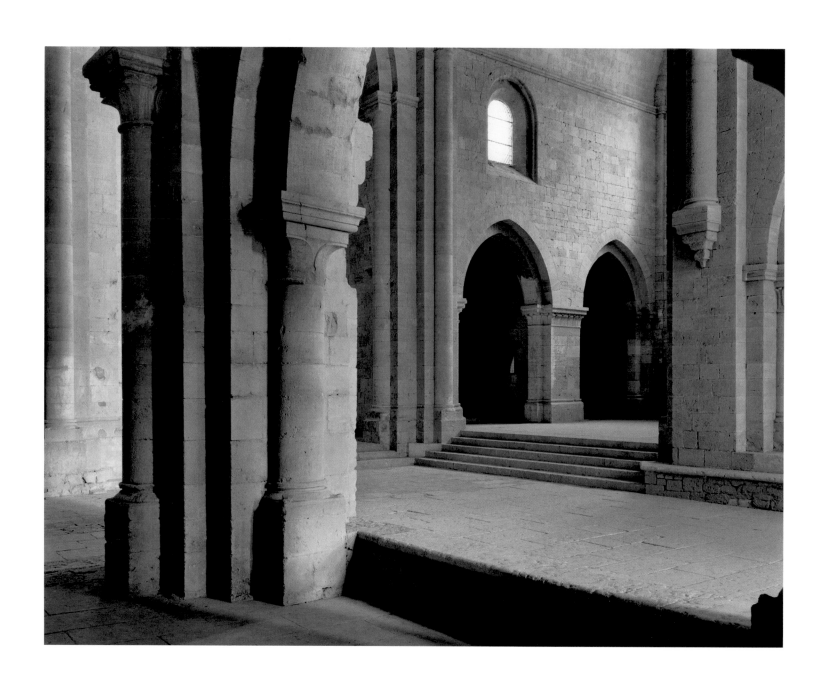

53. NAVE AND SOUTH TRANSEPT, SILVACANE, 1986

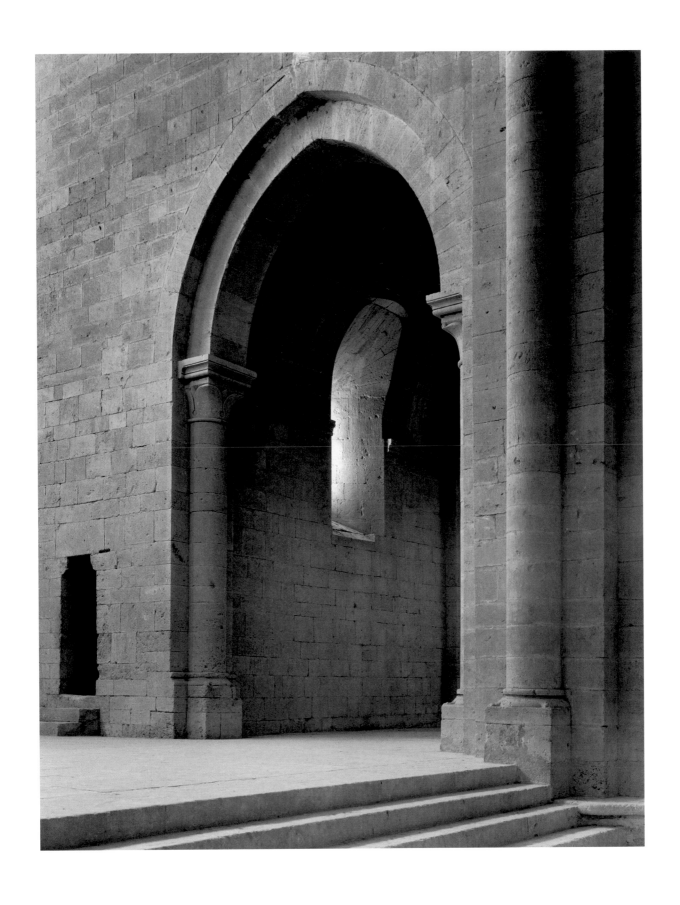

54. ENTRANCE TO THE SOUTH AISLE, SILVACANE, 1986

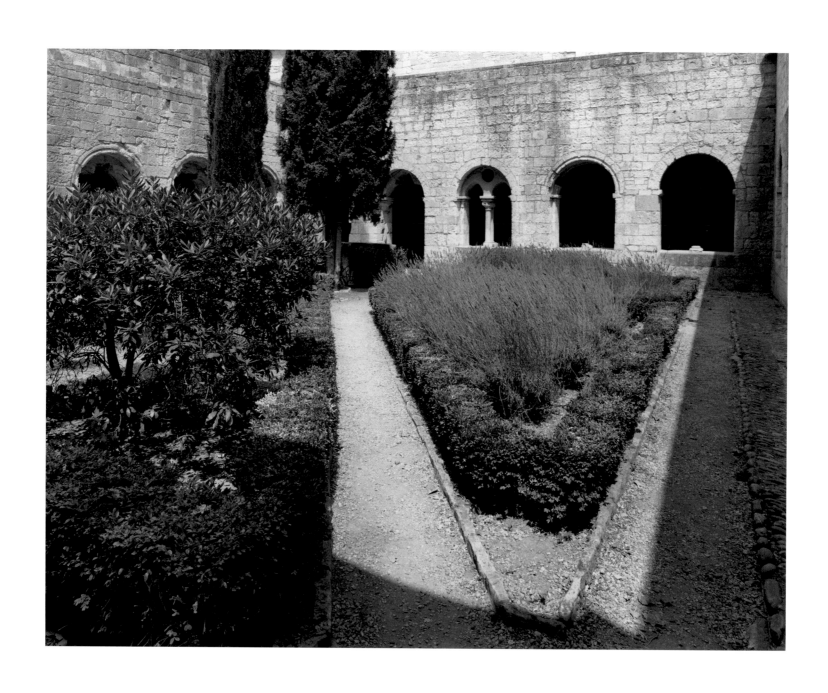

55. CLOISTER, SILVACANE, 1986

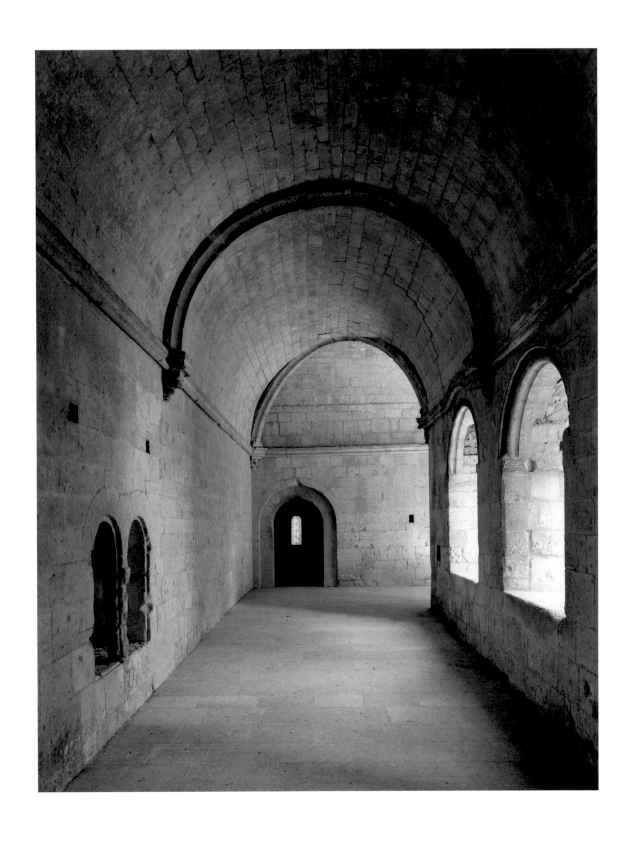

56. NORTH GALLERY OF THE CLOISTER, SILVACANE, 1986

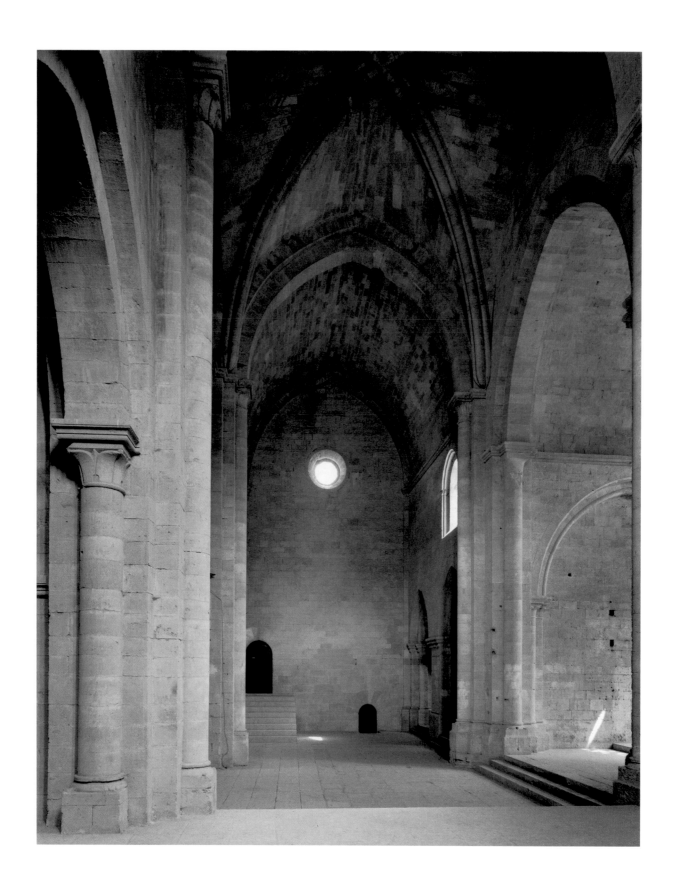

57. CROSSING, NORTH TRANSEPT AND NIGHT STAIRS, SILVACANE, 1986

NOIRLAC

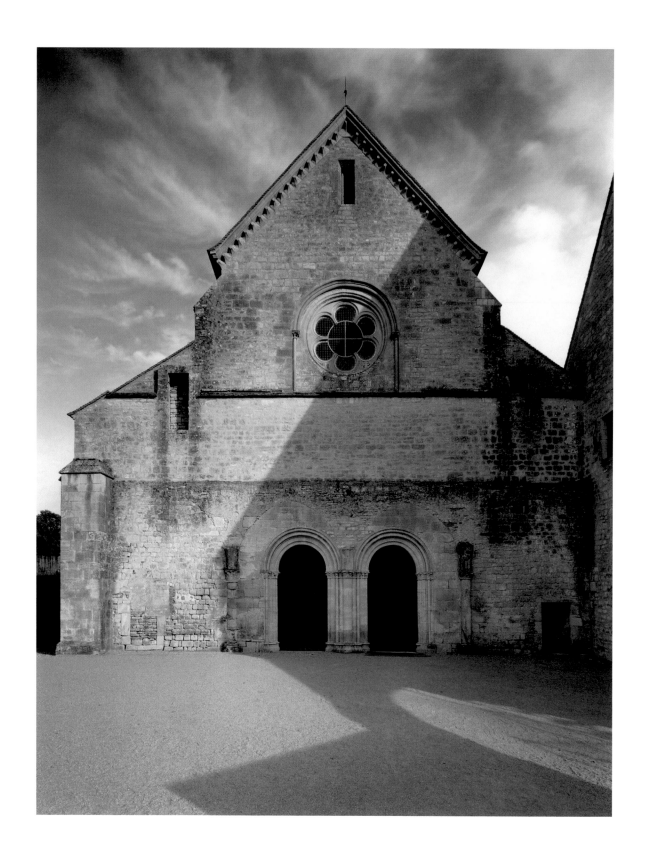

58. FAÇADE OF THE CHURCH, NOIRLAC, 1990

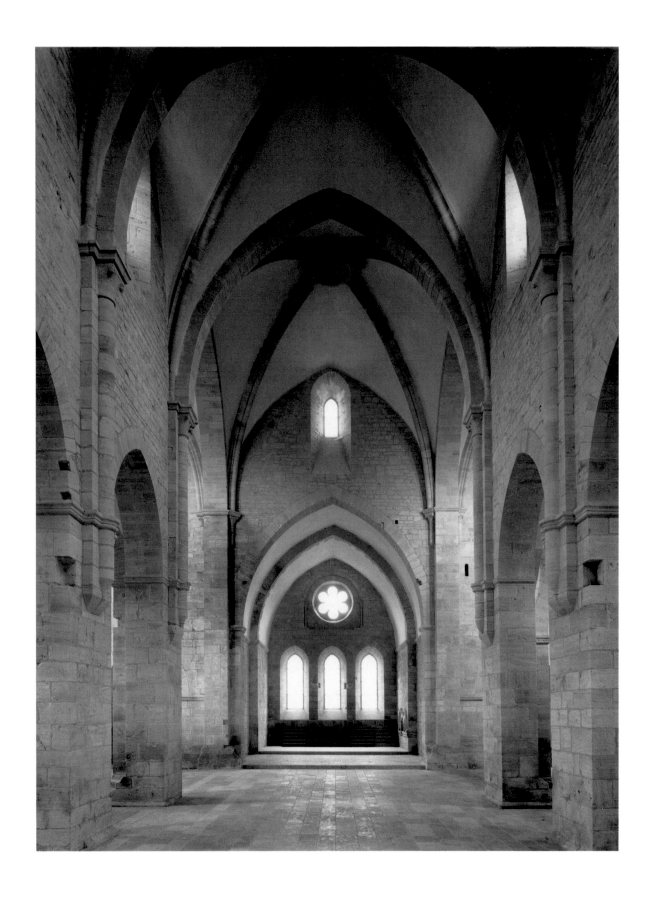

59. NAVE LOOKING EAST, NOIRLAC, 1990

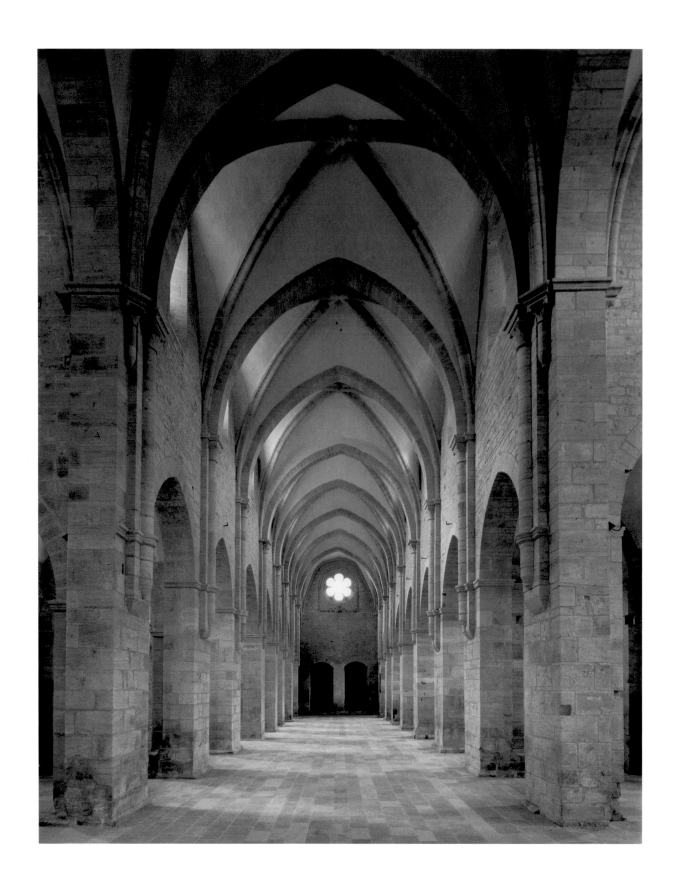

60. NAVE LOOKING WEST, NOIRLAC, 1990

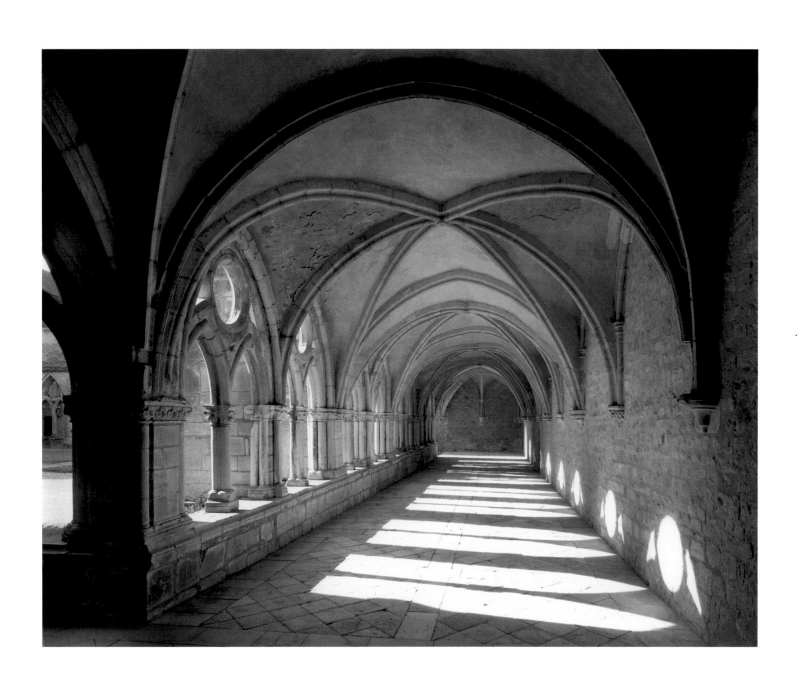

61. CLOISTER GALLERY, NOIRLAC, 1990

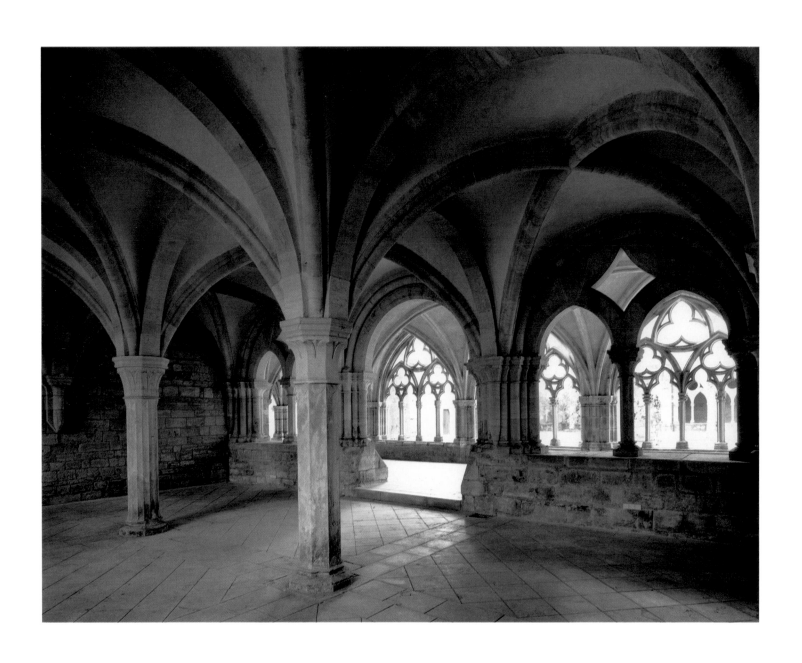

62. CHAPTER ROOM, NOIRLAC, 1990

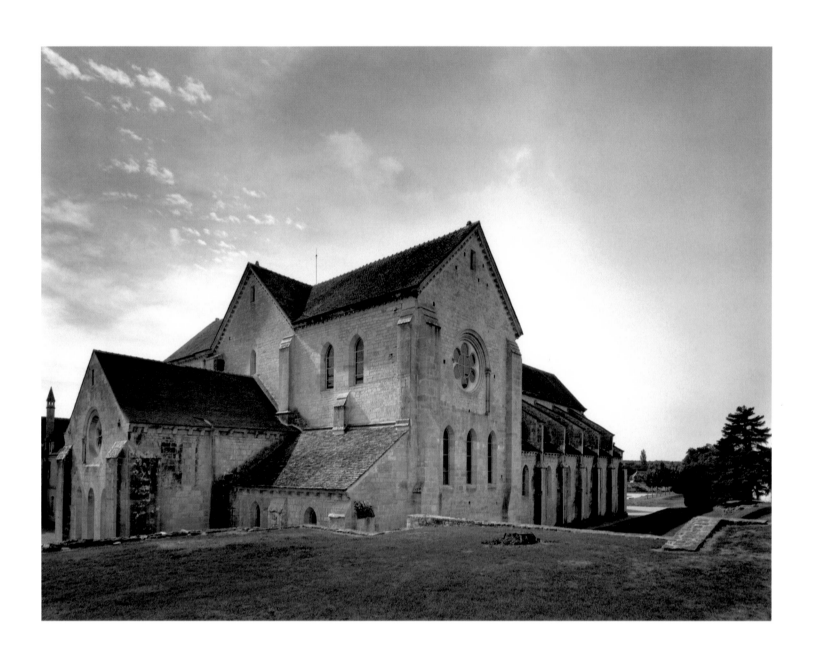

63. CHURCH FROM THE NORTHEAST, NOIRLAC, 1990

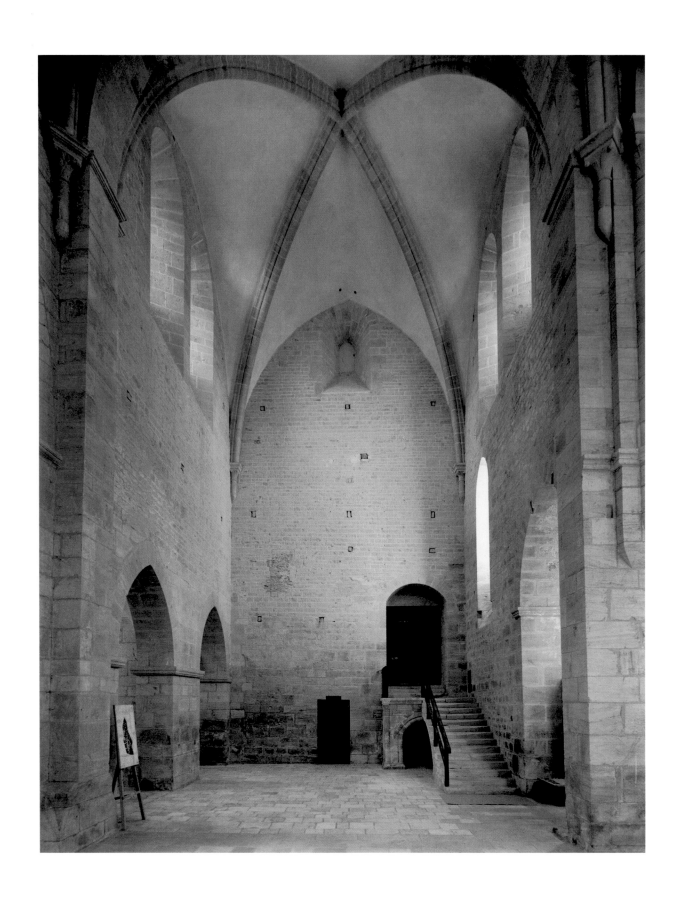

64. SOUTH TRANSEPT AND NIGHT STAIRS, NOIRLAC, 1990

PONTIGNY

FLARAN

CLAIRMONT

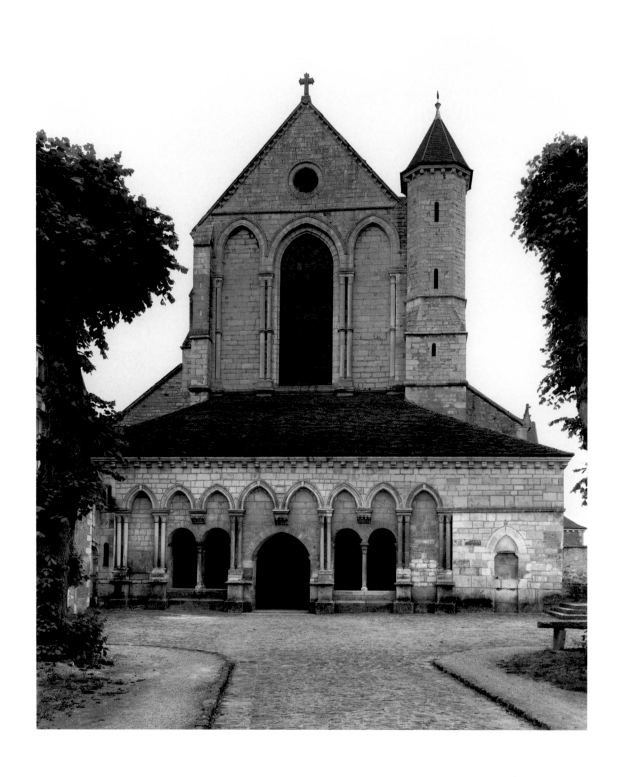

65. FAÇADE OF THE CHURCH, PONTIGNY, 1986

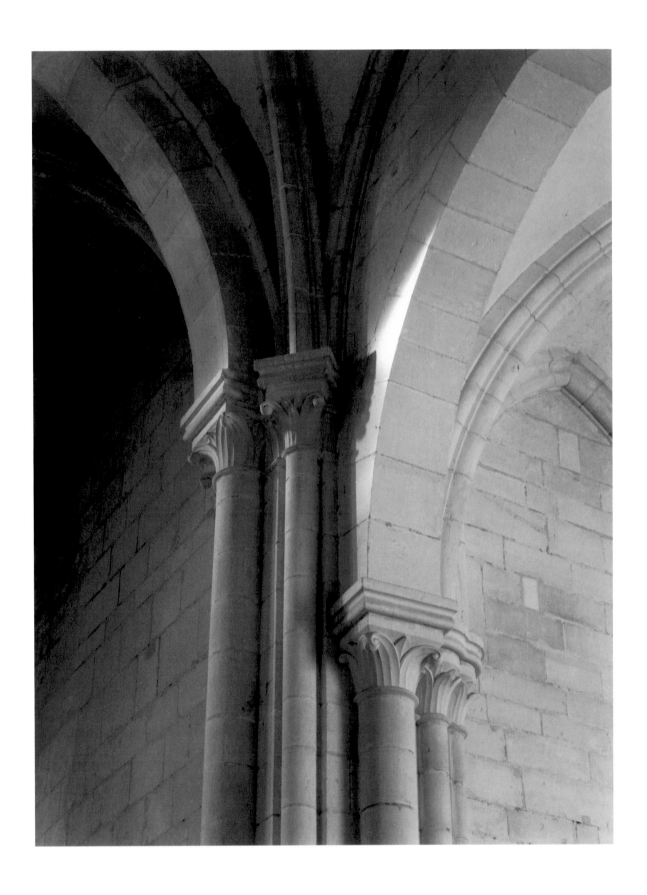

66. CAPITALS OF THE AMBULATORY, PONTIGNY, 1990

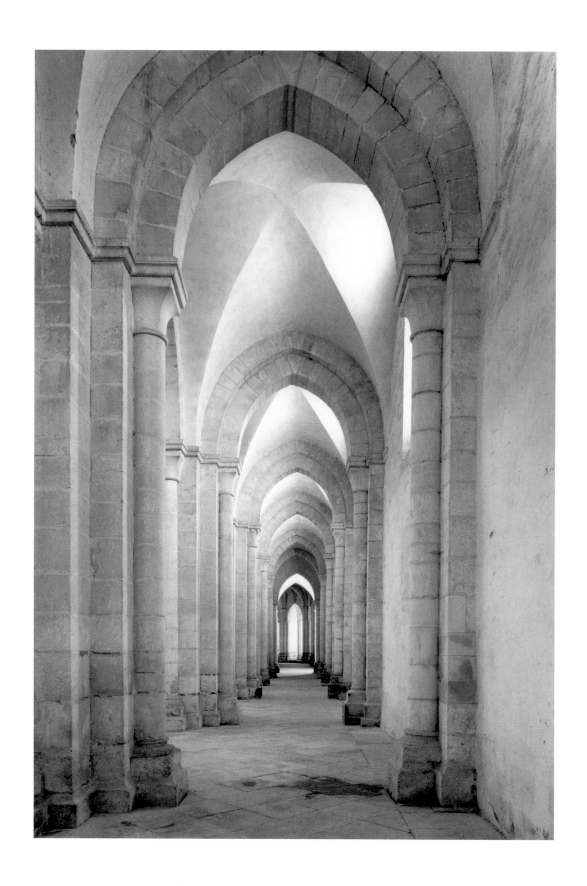

67. SOUTH AISLE LOOKING EAST, PONTIGNY, 1986

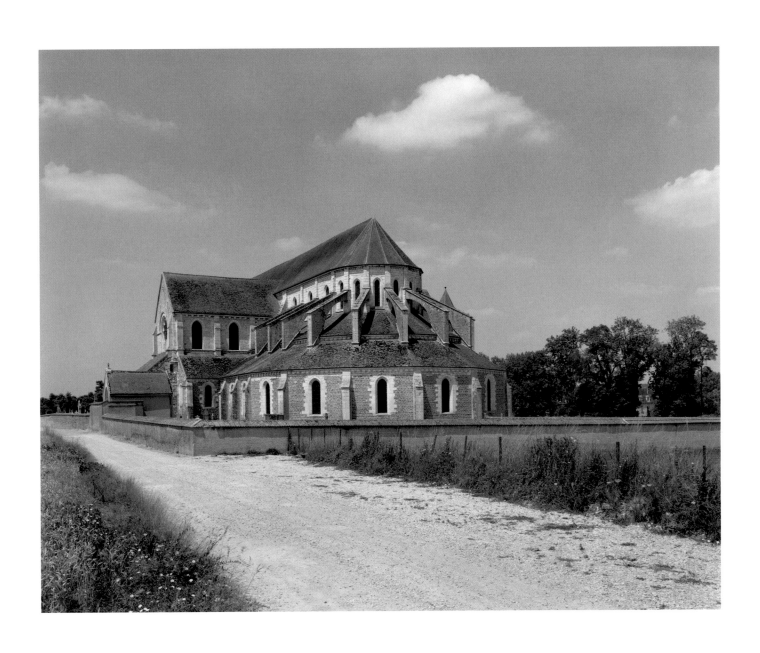

68. EXTERIOR OF THE CHURCH FROM THE SOUTHEAST, PONTIGNY, 1986

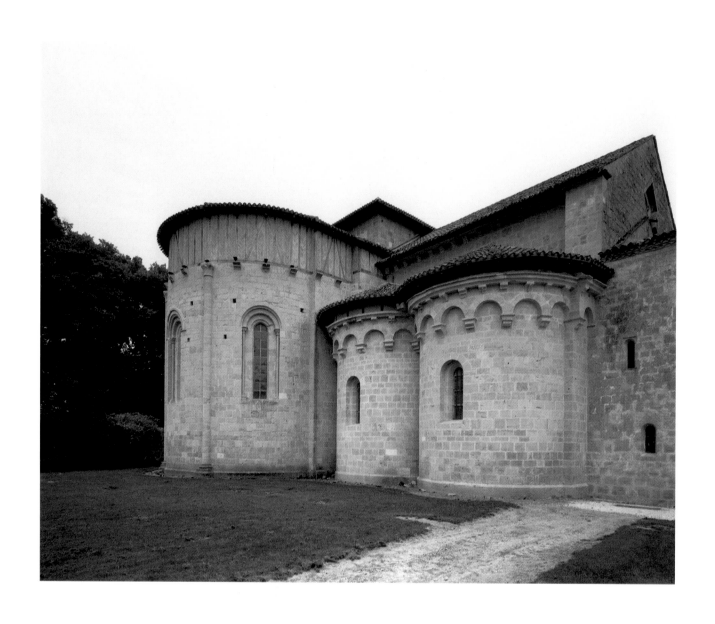

69. CHEVET AND CHAPELS OF THE NORTH TRANSEPT, FLARAN, 1995

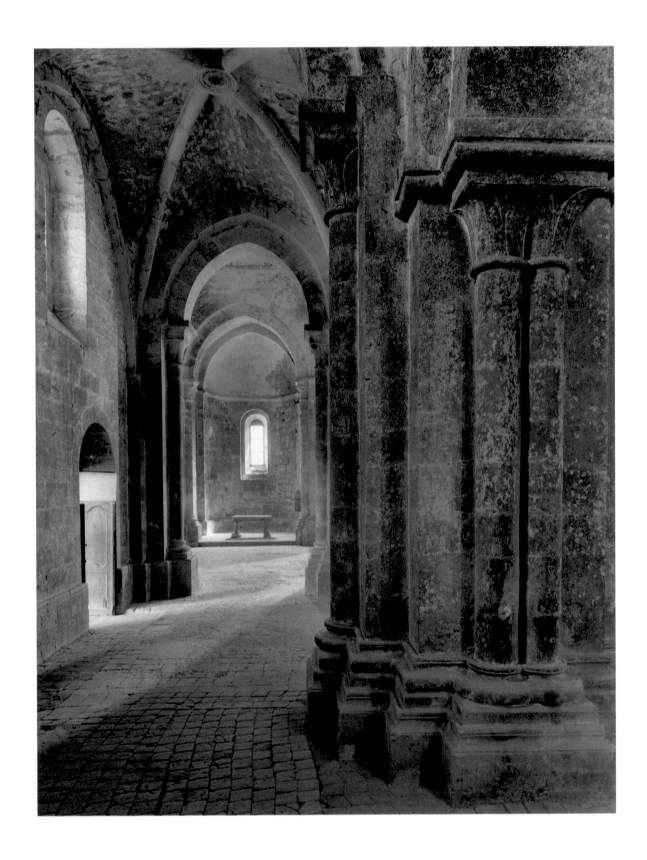

70. NORTH AISLE LOOKING EAST, FLARAN, 1989

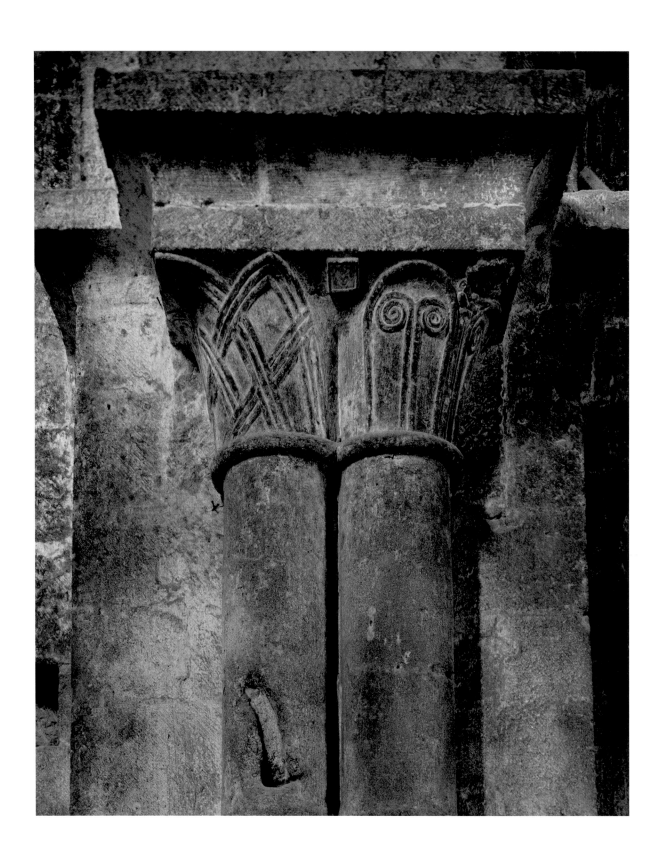

71. CAPITALS OF THE SOUTH AISLE, FLARAN, 1989

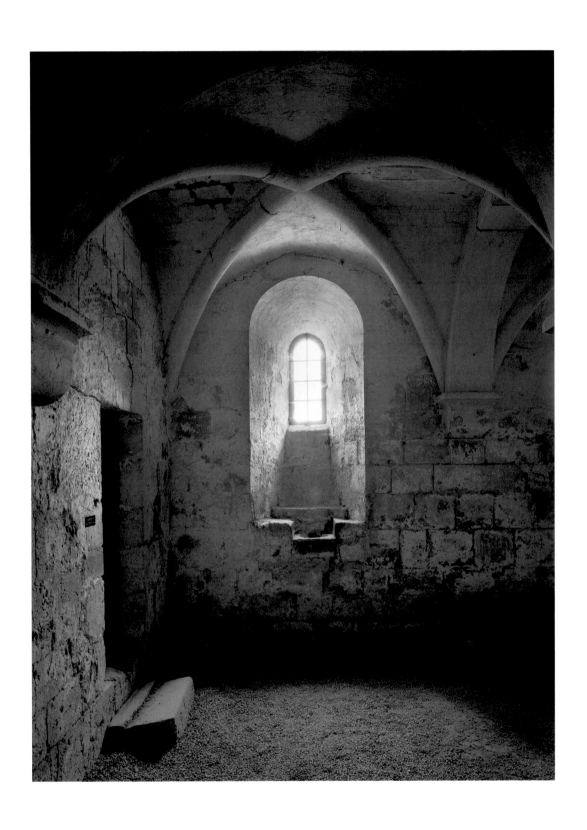

72. CHAPTER ROOM, FLARAN, 1995

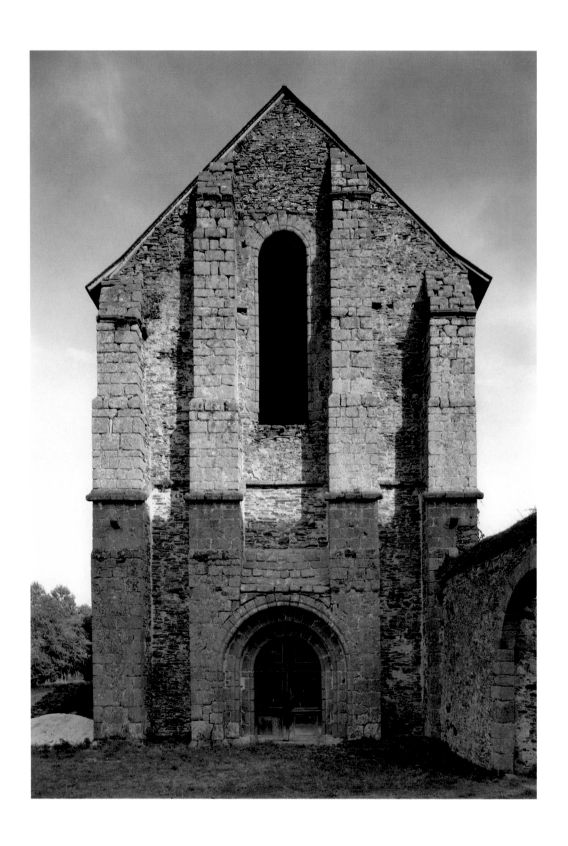

73. FAÇADE OF THE CHURCH, CLAIRMONT, 1990

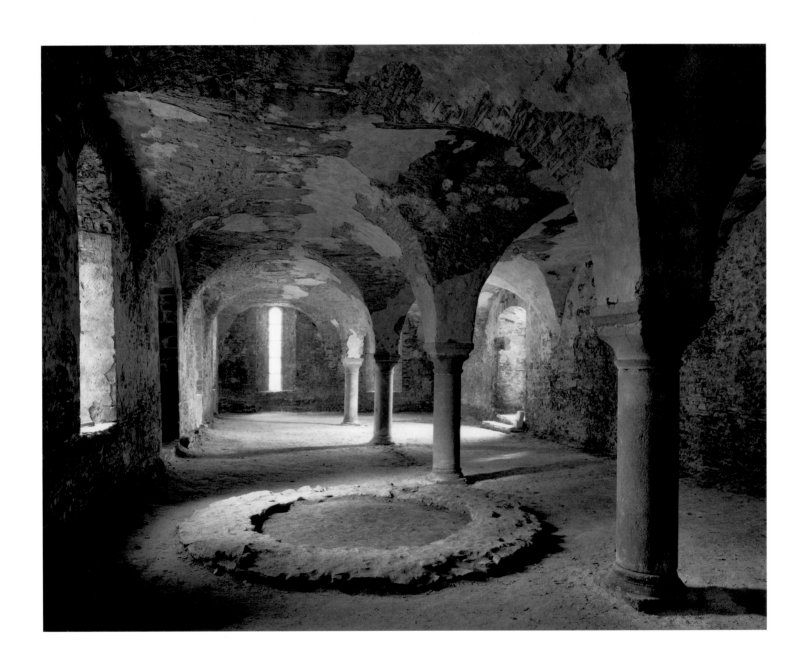

74. FOUNDATION OF A WINE PRESS (?). LAY BROTHERS' BUILDING, CLAIRMONT, 1990

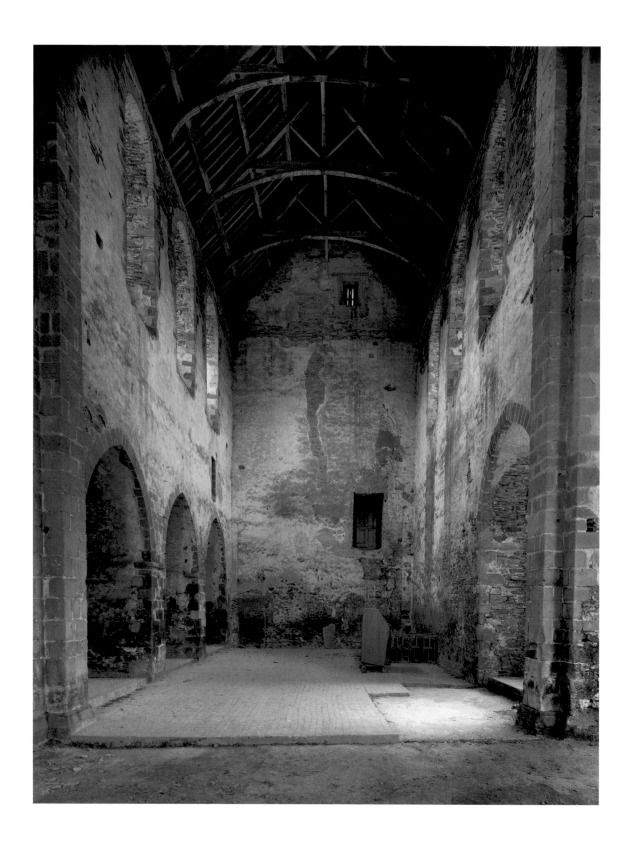

75. SOUTH TRANSEPT, CLAIRMONT, 1990

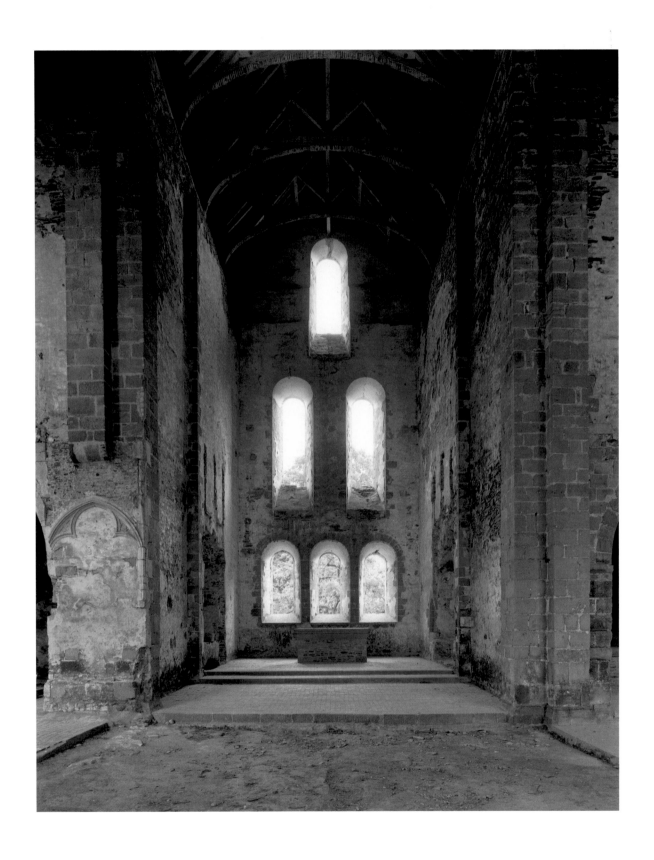

76. CHEVET, CLAIRMONT, 1990

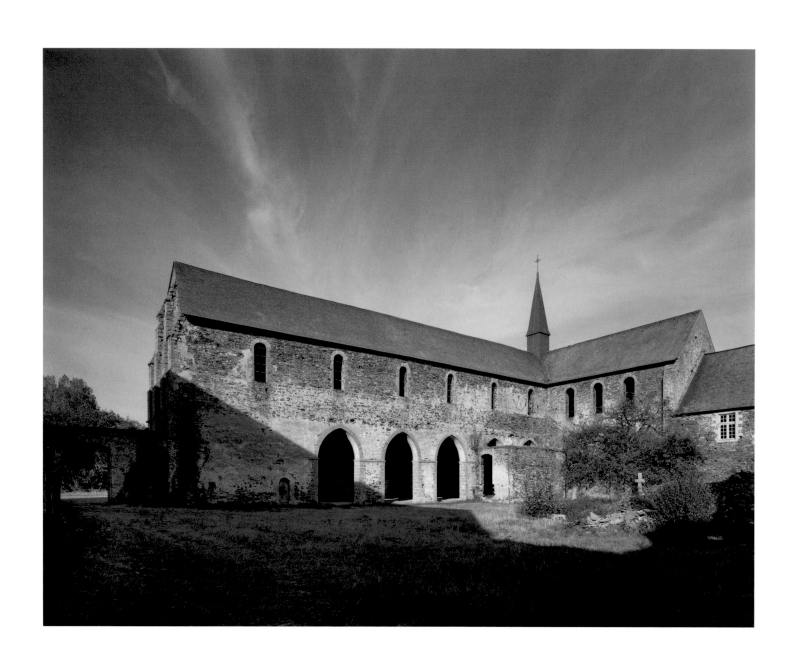

77. EXTERIOR OF THE CHURCH FROM THE SOUTHWEST, CLAIRMONT, 1990

FONTFROIDE

SILVANÈS

LOC-DIEU

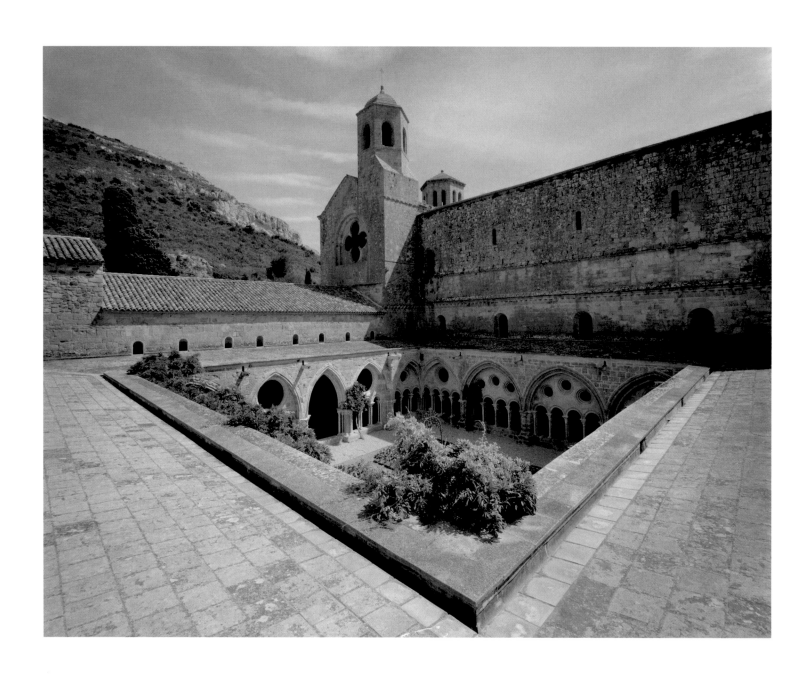

78. CLOISTER AND CHURCH, FONTFROIDE, 1995

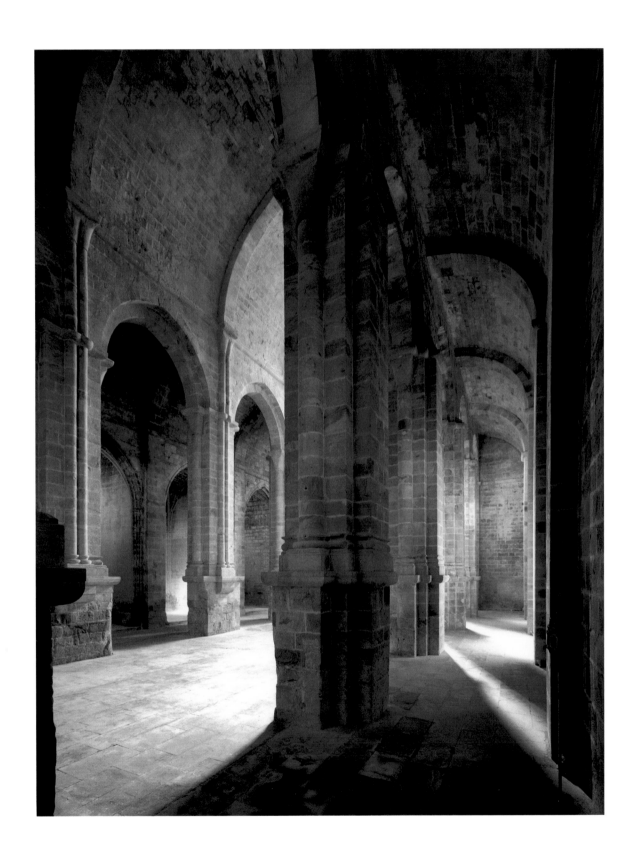

79. NAVE AND NORTH AISLE, FONTFROIDE, 1995

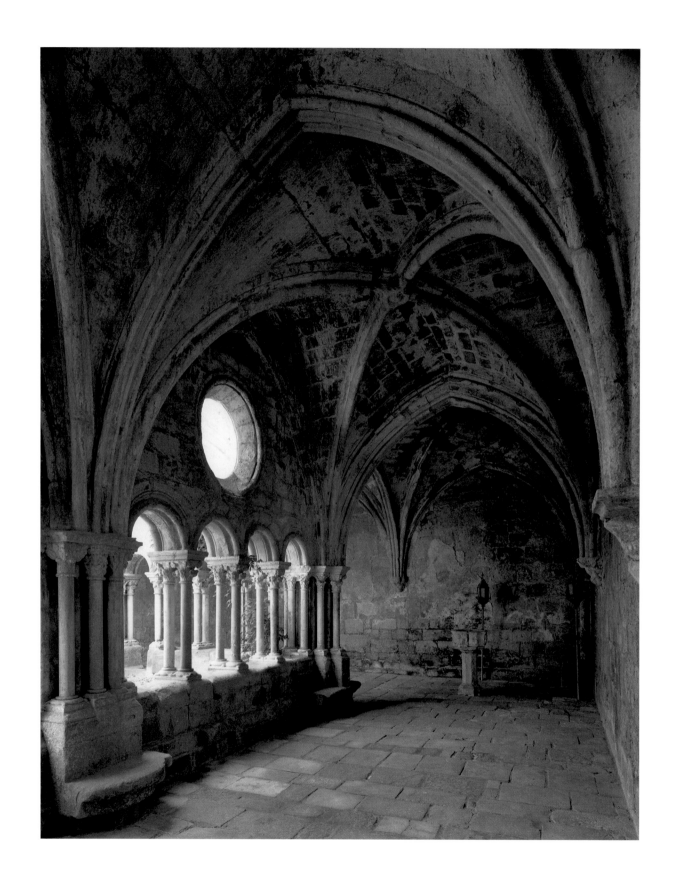

80. WEST CLOISTER GALLERY, FONTFROIDE, 1995

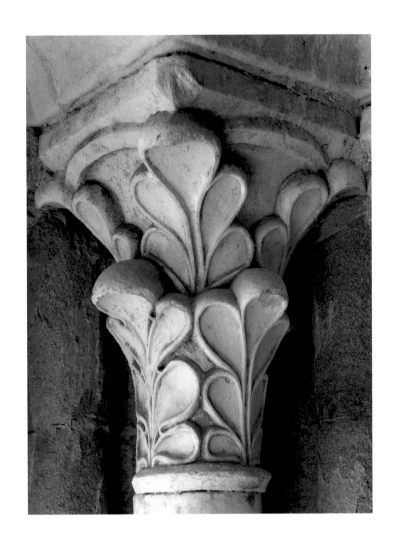

81. CAPITAL IN THE CLOISTER, FONTFROIDE, 1995

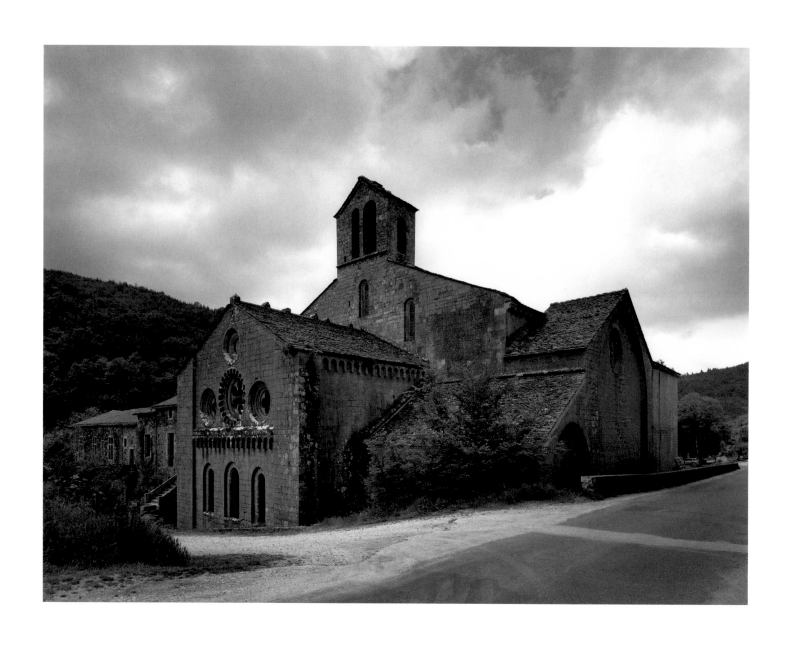

82. CHURCH FROM THE NORTHEAST, SILVANÈS, 1995

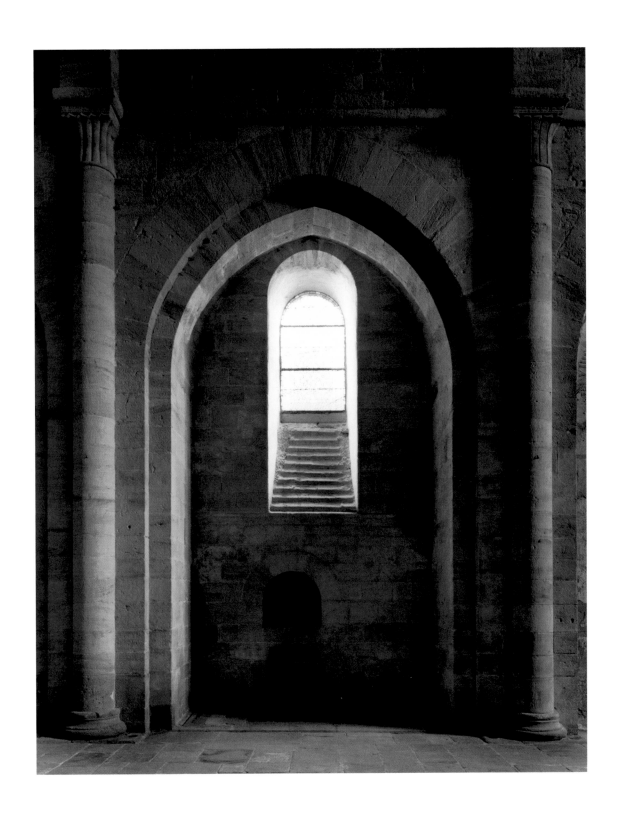

83. CHAPEL, SOUTH SIDE OF NAVE, SILVANÈS, 1995

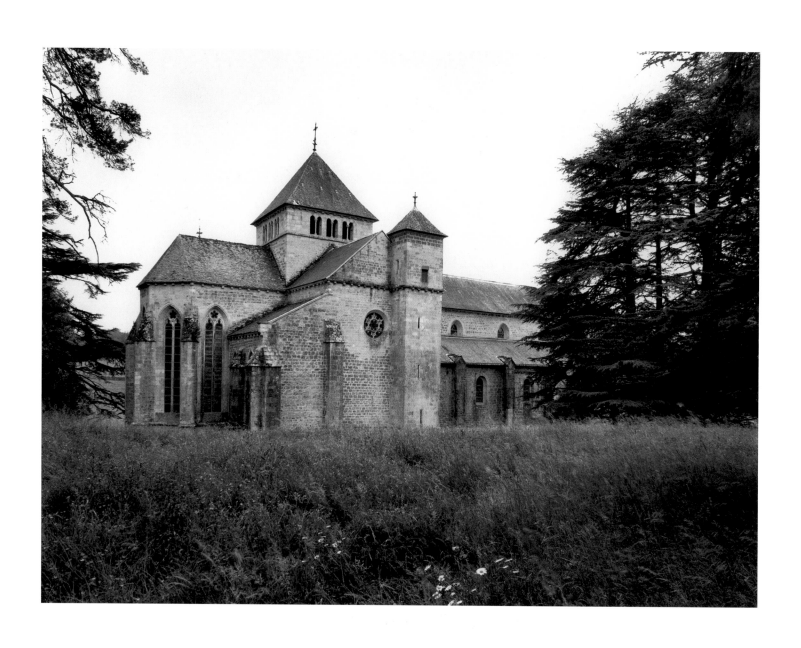

84. CHURCH FROM THE NORTHEAST, LOC-DIEU, 1989

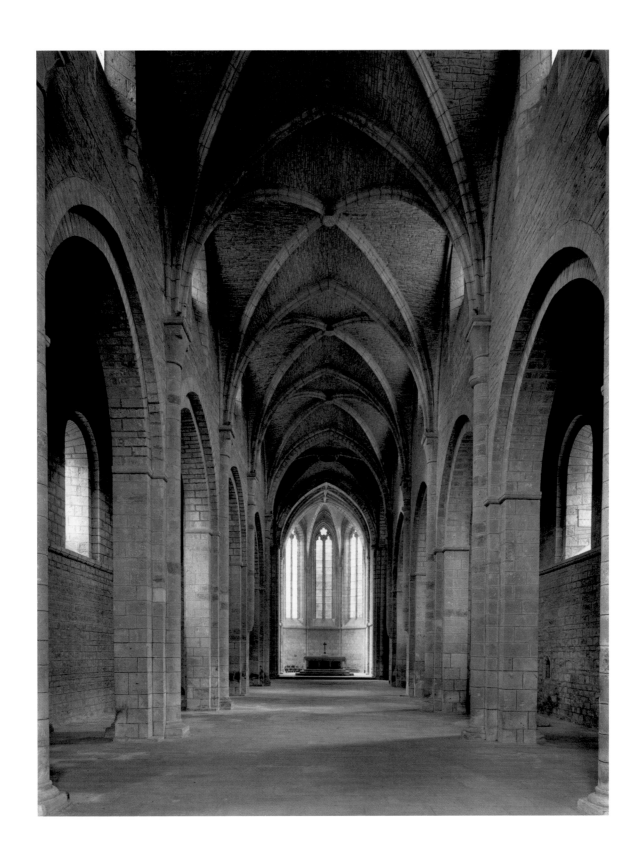

85. NAVE LOOKING EAST, LOC-DIEU, 1989

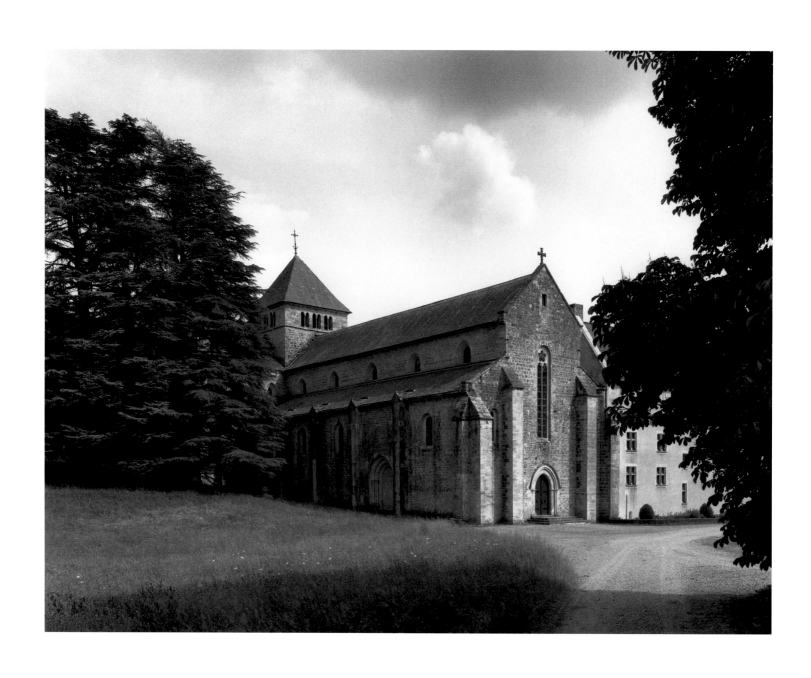

86. CHURCH FROM THE NORTHWEST, LOC-DIEU, 1989

RUINS

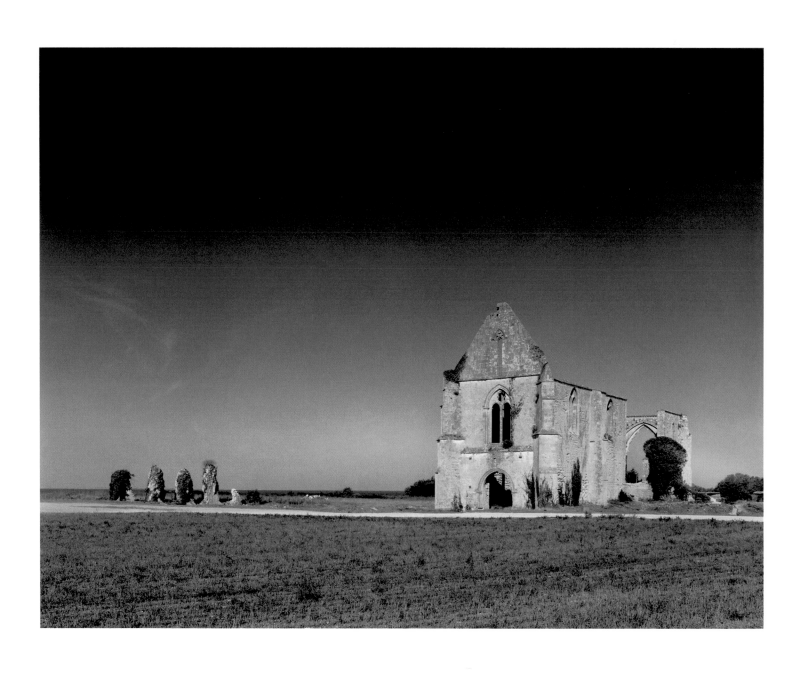

87. NOTRE-DAME-DE-RÉ, 1990

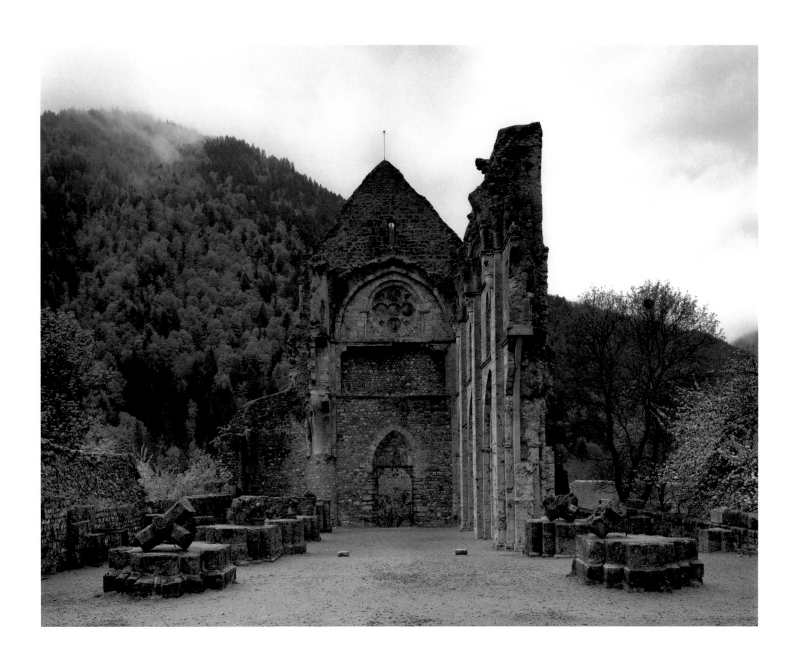

88. NAVE OF THE CHURCH LOOKING WEST, AULPS, 1995

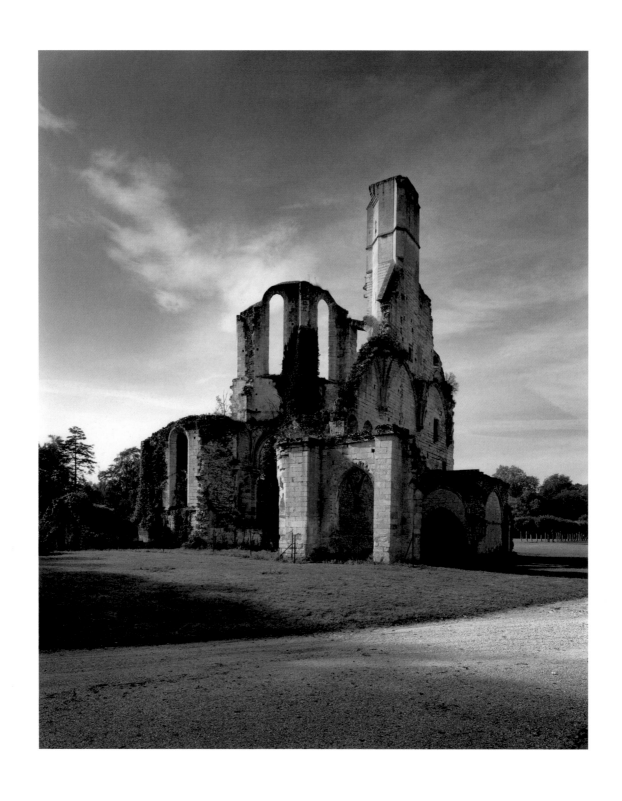

89. CHÂALIS, 1990

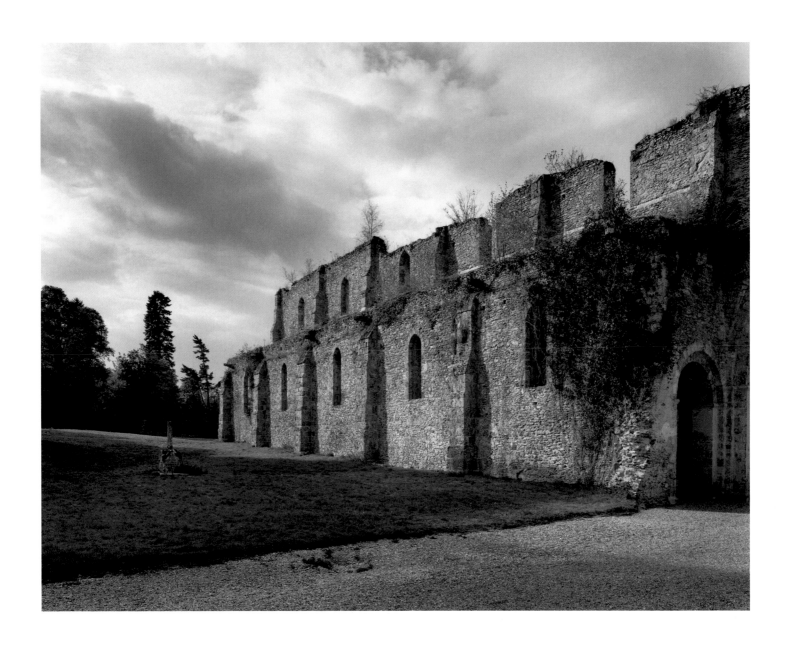

90. SOUTH FLANK OF THE CHURCH, LES VAUX-DE-CERNAY, 1990

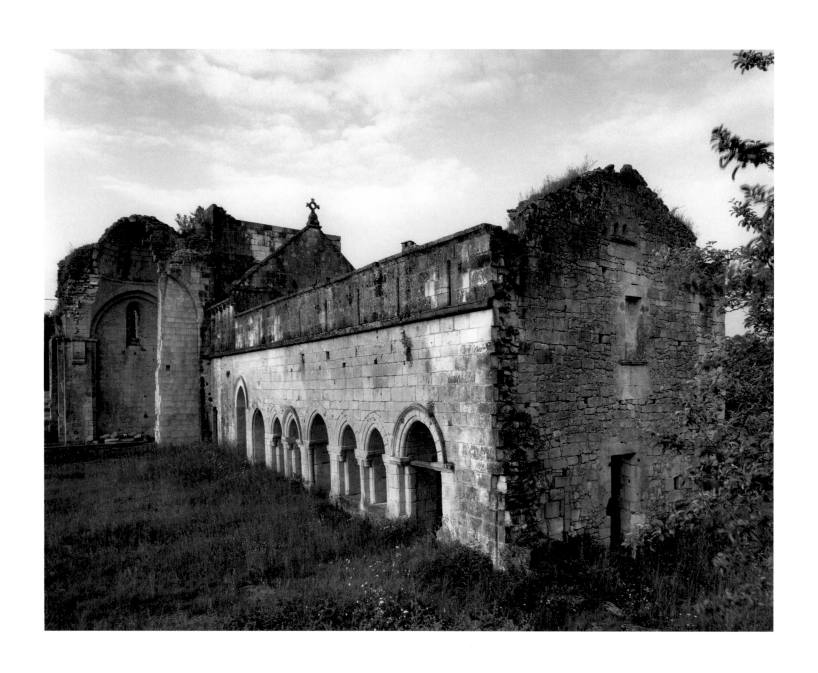

91. EAST RANGE OF THE CHURCH AND CLOISTER, BOSCHAUD, 1989

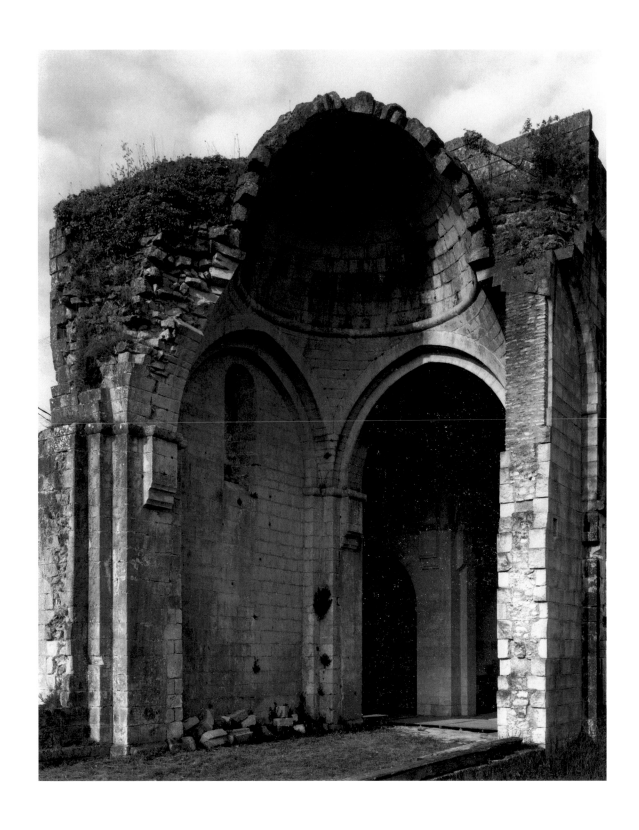

92. DOMED VAULT OF THE CHURCH, FIRST BAY OF THE NAVE, BOSCHAUD, 1989

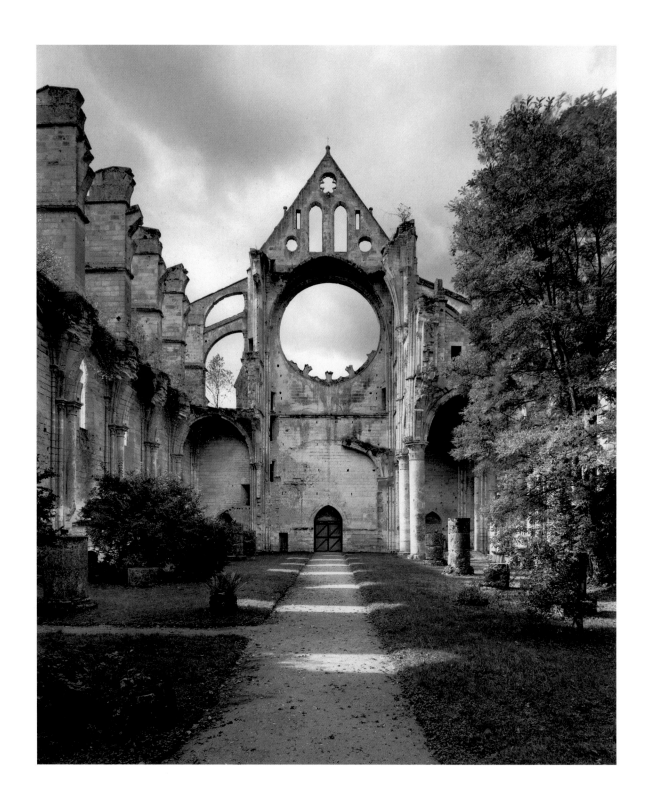

93. NAVE LOOKING WEST, LONGPONT, 1990

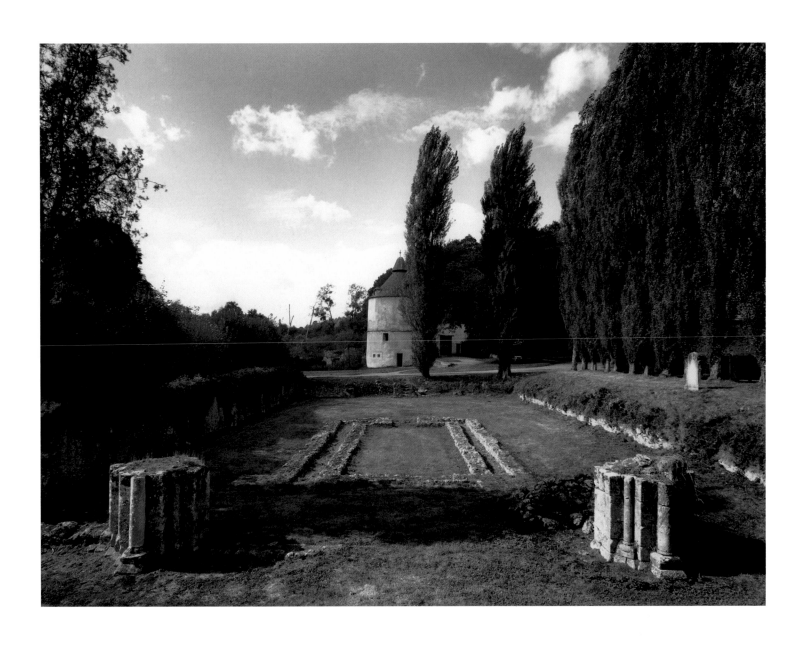

94. FOUNDATIONS OF THE CHURCH, PORT-ROYAL-DES-CHAMPS, 1990

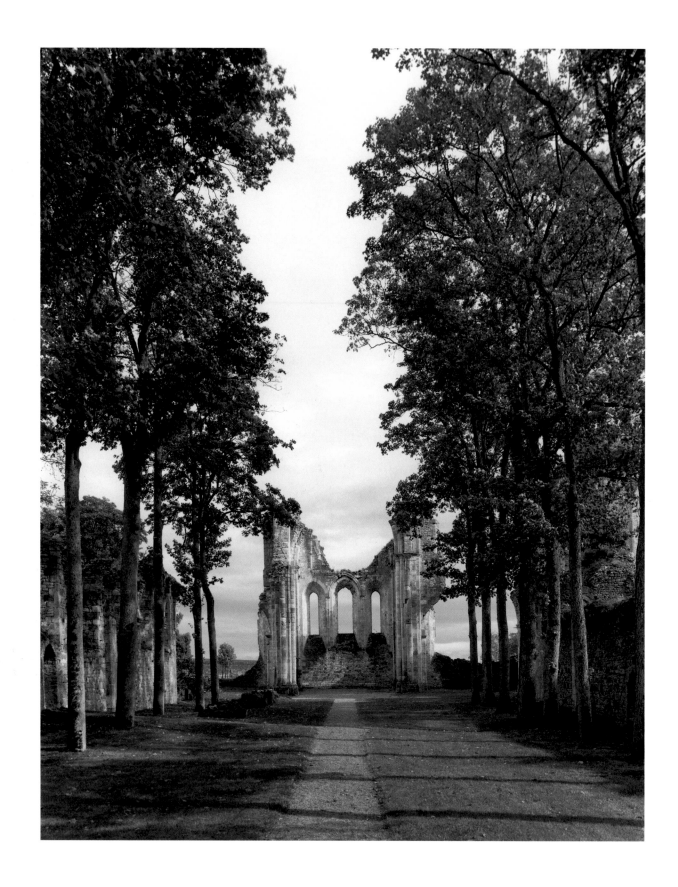

95. SITE OF THE NAVE LOOKING EAST TO THE CHEVET, PREUILLY, 1990

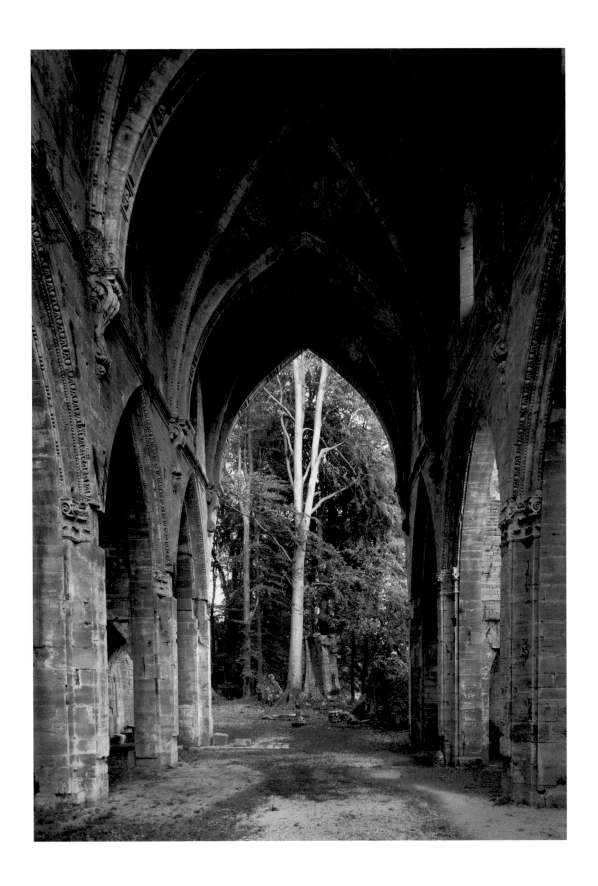

96. NAVE LOOKING EAST, TROIS-FONTAINES, 1990

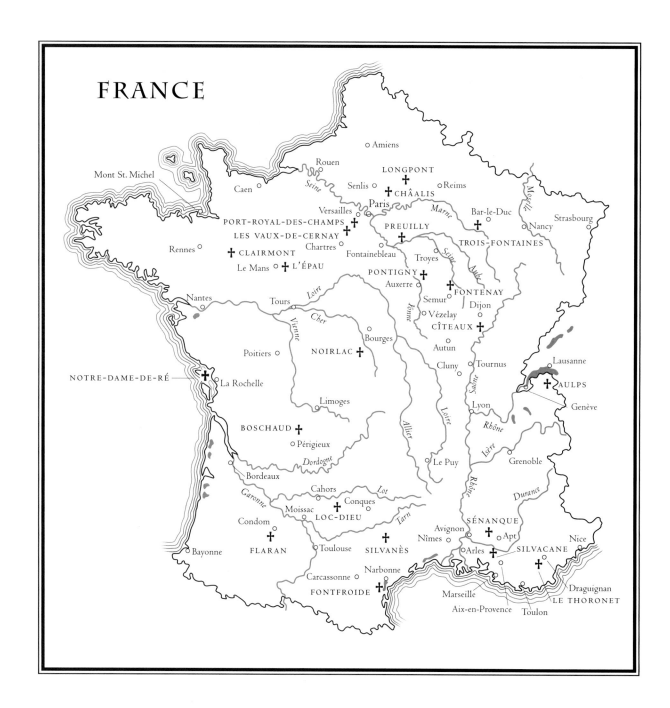

FRANCE

○ Amiens

Rouen ○
Senlis ○ **LONGPONT**
Caen ○ ✝ **CHÂALIS** ○ Reims
Mont St. Michel *Seine*
Paris ○ Bar-le-Duc
Versailles ○ *Marne* ✝
✝ **PORT-ROYAL-DES-CHAMPS** **PREUILLY** Nancy ○ Strasbourg
LES VAUX-DE-CERNAY ✝ **TROIS-FONTAINES**
Rennes ○ ✝ **CLAIRMONT** Chartres ○ *Seine*
Le Mans ○ ✝ **L'ÉPAU** Fontainebleau ○ Troyes ○
PONTIGNY ✝ *Aube*
Nantes ○ Auxerre ○ ✝ **FONTENAY**
Tours ○ *Loire* Semur ○ Dijon ○
Cher Vézelay ○
Vienne **CÎTEAUX** ✝
Bourges ○ Autun ○ Lausanne ○
Poitiers ○ **NOIRLAC** ✝ Cluny ○ Tournus ○
Saône ✝ **AULPS**
NOTRE-DAME-DE-RÉ ✝ La Rochelle Lyon ○ Genève ○
Limoges ○ *Rhône*
Allier *Isère*
BOSCHAUD ✝ *Loire* Grenoble ○
Périgieux ○ Le Puy ○
Dordogne *Rhône* *Durance*
Bordeaux ○ *Lot*
Cahors ○ *Conques* **SÉNANQUE**
Garonne Moissac ○ ○ ✝ Avignon ○ ✝ Apt Nice
Condom ○ **LOC-DIEU** Nîmes ○ ○ **SILVACANE**
✝ *Tarn* Arles ○ ✝ ✝ **SILVACANE** Draguignan ○
Bayonne ○ **FLARAN** Toulouse ○ **SILVANÈS** ✝ **LE THORONET**
Narbonne ○ Marseille ○
Carcassonne ○ **FONTFROIDE** ✝ Aix-en-Provence ○ Toulon ○

Mont St. Michel · *Seine* · *Moselle*

SITE LOCATIONS

ABBEYS: APPENDIX

AFFILIATION

The first Cistercian abbey (the mother-house of the Order) was the "New Monastery" of Cîteaux, founded in 1098, and the first four abbeys (or "daughter-houses") founded by Cîteaux were la Ferté (1113), Pontigny (1114), Clairvaux (1115), and Morimond (1115). Other monasteries were then founded from these first five abbeys, and all Cistercian monasteries for men trace their lineage back to one of them. (For example, Flaran was a daughter of l'Escale-Dieu, which was a daughter of Morimond; both abbeys are therefore said to belong to the filiation of Morimond.) Cistercian monasteries for women were usually dependant on the (men's) abbey that sponsored their foundation and are therefore not classified in the same way.

THE COMMENDATORY SYSTEM

In theory, abbots were freely elected by their communities, but in the Middle Ages, the doctrine of unlimited papal power led to an insistence on the part of the popes that they confirm all abbatial appointments. It was a but short step for popes (and, later, kings) to *appoint* abbots, rather than simply confirm them in their position. Abbots so appointed were known as "commendatory abbots," and their abbeys were said to be held *in commendam*. The word *commenda* means "something entrusted," and – theoretically – commendatory abbots were entrusted with the overall running of a monastery. Most did not fulfill this trust; they rarely lived in the abbey and often were no more than absentee landlords whose only interest was in appropriating whatever revenues the abbey could provide. By the end of the sixteenth century nearly all French abbeys were *in commendam* and this system dominated French monastic life until the Revolution.

ABBREVIATIONS:

F. filiation of one of the first five abbeys,
 Cît: Cîteaux
 laF: la Ferté-sur-Grosne
 P: Pontigny
 Cl: Clairvaux
 M: Morimond
D. *département*
C. commune

AULPS (F. Cl; D. Haute-Savoie; C. Saint-Jean d'Aulps) was founded at the end of the eleventh century as a Benedictine abbey and became Cistercian in 1136. For two centuries the abbey prospered, but in the fourteenth century it became impoverished, and the situation was exacerbated by the commendatory system. In 1689 Aulps was pillaged and in 1702 some buildings were destroyed by fire. The lovely ruins of the church in its Alpine setting are open to visitors today. The most important person associated with Aulps was Saint Guérin, the second abbot.

BOSCHAUD (F. Cl; D. Dordogne; C. Villars) was initially a hermitage dating from the early twelfth century. It became Cistercian in

1163 but had a tumultuous history. In the mid-thirteenth century there was a revolt of lay-brothers, and in 1290 the house was so poor that for a time it was abandoned. In the mid-fourteenth century it was sacked by brigands, and by the end of the fifteenth century was in deplorable condition. It suffered much during the Hundred Years' War and the Wars of Religion, and after it was pillaged by the Huguenots in the sixteenth century, it never really recovered. Recently liberated from the shrubbery and brambles which had grown over the site, the surviving buildings and ruins are currently being evaluated for restoration.

CHÂALIS (F. P; D. Oise; C. Fontaine-Châalis) began as a Benedictine priory and was transferred to the Cistercian Order in 1136 through the generosity of King Louis VI, and endowed still further by his son Louis VII. The abbey thus had an abundant financial base, and major rebuilding in the Gothic style was undertaken in the late twelfth and thirteenth centuries; the new church was one of the largest of the Order, measuring 266.5 feet (82 m) in length. Châalis was *in commendam* in 1541 and a number of commendatory abbots enlarged the site with a series of magnificent buildings. Unfortunately, the expenses ruined the abbey. It was sold at the Revolution and the church and other buildings were dismantled in order to re-sell the building materials. Châalis was purchased by Mme. Nelly Jacquemart in 1902 and, at her death in 1912, bequeathed to the Institut de France; the Musée Jacquemart-André, which houses the collections of Mme. Jacquemart and of J.-J. Rousseau, is located

on the site. Imposing ruins and an immense park remain. Châalis was also an important intellectual center and produced a number of Cistercian writers of whom the best known is the poet Guillaume de Digulleville (1295–1358).

CÎTEAUX (D. Côte-d'Or; C. Saint-Nicolas-lès-Cîteaux), the mother-house of the Cistercian Order, was founded in 1098. The first site, at La Forgeotte, soon proved unsatisfactory and the abbey was moved approximately one mile south to its present location. Ambitious building programs were carried out from the twelfth century onward, but the abbey suffered much during the Hundred Years' War and the Wars of Religion. In the eighteenth century, plans were made by the Dijon architect Nicolas Lenoir for an enormous neo-classical rebuilding of the entire complex, but only one half of one wing of the mammoth project was completed. At the Revolution the abbey was sold; the medieval buildings were demolished in the course of the nineteenth century to adapt the site to various uses. It served as a phalanstery and then a penal colony for delinquent children. In 1898 the property was purchased by the Cistercian Order of the Strict Observance (Trappists) and remains a Cistercian abbey today. The first three abbots of Cîteaux — Robert of Molesme, Alberic, and the Englishman Stephen Harding — were canonized.

CLAIRMONT (F. Cl; D. Mayenne; C. Le Genest) was founded *c.* 1152 as a daughter of Clairvaux. The history of the abbey was uneventful and in about 1513 it was placed *in*

commendam. By 1567 it seems to have been deserted, but was resettled by a handful of monks who continued the offices until the Revolution. It was then sold and made into a farm. The abbey produced no notable figures and its intellectual life, like its history, appears to have been undistinguished. The many remaining abbey buildings were purchased in 1954 and have been under restoration since that time.

L'ÉPAU or PIÉTE-DIEU (F. Cît; D. Sarthe; C. Yvré-l'Évêque) was founded by Queen Berengaria of Navarre, widow of Richard the Lion-Hearted, for monks from Cîteaux. The church was dedicated in 1234 before construction was finished. In 1365, during the Hundred Years' War, the inhabitants of nearby Le Mans set fire to the abbey to prevent it from falling into the hands of the English. Reconstruction was long and difficult, lasting until the middle of the fifteenth century; the immense window visible today in the apse of the church was added during this rebuilding campaign. The abbey was sold at the Revolution and remained private property until 1958 when it was purchased by the *département* and restored.

FLARAN (F. M; D. GERS; C. Valence-sur-Baïse) was founded *c.* 1151 as a daughter of l'Escale-Dieu. Until the first decades of the thirteenth century the abbey benefited from generous donations, but after that its history was sorely troubled. Its lands were ravaged, and during the Hundred Years' War it was sacked by the English. It was *in commendam* by the end of the fifteenth century, and suffered again during the Wars of Religion. At the Revolution the buildings were sold and, as was common at the time, turned into a farm. Property of the *département* since 1970, the abbey has been restored and provides an excellent example of Cistercian construction in southwest France.

FONTENAY (F. Cl; D. Côte-d'Or; C. Marmagne) was founded in 1119 on the site of an old hermitage. It was the second daughter-house of Clairvaux and the land had been given by Bernard's maternal uncle. The original site, however, proved unsatisfactory, and in 1130 the abbey was moved a short distance to its present location where land was donated by another of Bernard's uncles. For some two centuries Fontenay prospered, but from the fourteenth century it suffered much from war and pillage, and was sacked a number of times. It was *in commendam* from 1516. At the Revolution the property was sold and turned into a paper factory. Designated World Heritage Patrimony by UNESCO in 1988, Fontenay presents a remarkably complete example of a Burgundian Cistercian abbey of the mid-twelfth and thirteenth centuries, with cloister and three ranges of surrounding buildings, gatehouse and medieval forge.

FONTFROIDE (F. Cl; d. Aude; C. Bizanet) was founded *c.* 1093 as a Benedictine monastery, but in 1145 it followed in the footsteps of Grandselve and changed its allegiance to the Order of Cîteaux with Grandselve as its mother-house. For more than two centuries Fontfroide enjoyed an enviable prosperity. It was a fortress of orthodoxy during the Cathar heresy and two of its monks were

chosen as papal legates. In 1371 it was pillaged and during the papal schism its goods were sequestered and one abbot deposed and excommunicated. By 1476 it was *in commendam*, and its history until the Revolution is one of misfortune. The many granges and vineyards were sold at the Revolution, but the abbey buildings did not tempt a bidder and the city of Narbonne retained possession, converting it into an (unsuccessful) almshouse, then catering to contemporary taste for romantic ruins by selling off elements of the cloister piecemeal. Fontfroide was sold to a second Cistercian community in 1858 and they lived within its walls until the definitive separation of church and French state in 1901. The abbey then narrowly escaped purchase by the American sculptor, George Grey Barnard, whose collection of medieval antiquities now forms an important part of The Cloisters Collection in New York. It was acquired by a local family in 1908. A spectacular witness to the evolution of Cistercian architecture at a single site, Fontfroide still has its medieval church, cloister and claustral buildings including an immense lay brothers' complex, plus neo-classical courtyard and terraced gardens. One of the fourteenth-century abbots of Fontfroide, Jacques Fournier, was elevated to the papacy as Benedict XII.

LOC-DIEU (F. P; D. Aveyron; C. Martiel) was founded in 1124 by monks from Dalon, and passed into the Cistercian Order along with Dalon (and five other abbeys) in 1162. Its early years were plagued by financial problems, but once these had been overcome, the abbey prospered until the Hundred Years' War when

it was sacked and burned in 1411. The restored abbey was *in commendam* from 1557, and four years later it was pillaged by the Huguenots. At the Revolution the dilapidated buildings were sold and turned into a farm. It was later purchased by a family that made concerted efforts in 1847 and 1885 to restore and remodel the abbey. In 1940, Loc-Dieu sheltered briefly some of the most important paintings of the Louvre (including *Mona Lisa* and *The Marriage of Cana*). Today the early Gothic church, as well as three fifteenth-century galleries of the cloister and some surrounding buildings, including chapter room and refectory, remain.

LONGPONT (F. Cl; D. Aisne; C. Longpont) was founded in 1132 by Bernard of Clairvaux. It was a rich abbey and its architecture imposing, but it suffered much in the wars which ravaged the region, being sacked by the English in 1356, by the Burgundians in 1414, and by the Huguenots in 1567. There was a fire in 1724, and after the Revolution the buildings were used as a quarry; there was also bomb damage in 1918 and 1940. It is astonishing that so much has survived, including ruins of the church, the cloister, and claustral buildings, and a fortified gatehouse.

NOIRLAC (F. Cl; D. Cher: C. Saint-Amand-Montrond), a daughter of Clairvaux, was founded *c.* 1136 but its early history is obscure. It was occupied in the course of the Hundred Years' War, fortified in 1423, and attacked by the Huguenots in 1562, who destroyed the porch of the church and burned the lay-brothers' building. In the eighteenth century there was considerable restoration under numerous com-

mendatory abbots. The abbey was abandoned at the Revolution; ovens for a porcelain factory were installed in the church in 1822. The abbey was purchased by the *département* of the Cher in 1909 and a full restoration of the ensemble was begun in 1949. Lasting nearly 30 years, the work encompassed a large and complex set of buildings, including the church and three ranges of buildings around the cloister.

Notre-Dame-de-Ré or les Châtelliers (f. P; d. Charente-Maritime; c. Sainte-Marie-de-Ré) was founded in 1156 as a daughter-house of Pontigny. Located on an island opposite La Rochelle, it suffered again and again from pillage and occupation by English armies. The abbey was rebuilt numerous times, but in 1574–75 it was sacked by the Huguenots, and in 1623 the monks gave up the struggle and left. The abbey was then united with the Oratory in Paris but in 1627 the buildings were again destroyed by the English. Ruins of the medieval church still stand up to the level of the vaults, but a nearby fort was largely built with stones from the cloister buildings. Its first abbot was Isaac of Stella, one of the most renowned Cistercian writers of the twelfth century.

Pontigny (d. Yonne; c. Pontigny) was founded in 1114 as the second daughter of Cîteaux and became in turn the head of a filiation of forty-four abbeys in France, Italy and Hungary. An ambitious building program was carried out in the course of the twelfth century, including an experiment in covering the immense church with ribbed vaults that marks the introduction of Gothic architec-

ture into Burgundy. For some 200 years the abbey flourished. In the fourteenth century, however, it was ravaged by famine, plague, and the Hundred Years' War; in the following century it suffered from neglect by commendatory abbots; and then, in the 1560s, it was attacked by the Huguenots. With the restoration of regular abbots in the seventeenth century there was a great deal of rebuilding, including a new cloister. In the twelfth and thirteenth centuries, Pontigny had offered refuge to three English archbishops – Thomas Becket, Stephen Langton, and Edmund of Abingdon – and on his death in 1240, the body of the future Saint Edmund was laid to rest in the abbey church where it remains to this day.

Port-Royal-des-Champs (d. Yvelines; c. Magny-les-Hameaux) was founded in 1204 by Mathilde de Garlande as a Benedictine nunnery. In 1225 it was attached to the Cistercian Order and its material and spiritual welfare entrusted to the abbot of les Vaux-de-Cernay, Thibault, grandson of the founder Mathilde. The abbey received generous donations, but the damage it sustained during the Hundred Years' War required major reconstruction in the sixteenth century. In 1608 the community was reformed by the abbess Angélique Arnauld, and in 1625 was transferred to Paris. Port-Royal-des-Champs was then occupied by the celebrated "Solitaires" of Port-Royal, but their deep involvement in the Jansenist controversy led to the suppression of the abbey in 1709. In 1710 the claustral buildings were demolished and the site profaned.

PREUILLY (F. Cît; D. Seine-et-Marne; C. Egligny) was founded in 1118 as the fifth daughter of Cîteaux. Munificent royal donations made the abbey rich and prosperous, but during the Hundred Years' War it was sacked by the English, and the commendatory system was introduced in 1536. In the seventeenth century the abbey was again burned and pillaged, and although the ruined buildings were rebuilt in the first decades of the eighteenth century, much of the abbey was demolished after the Revolution. One thirteenth-century abbot of Preuilly, Humbert, was a well-known scholastic philosopher and theologian. The twelfth-century church, though in ruins, still conveys an accurate picture of the elegant construction of early Gothic Cistercian architecture.

SÉNANQUE (F. Cît; D. Vaucluse; C. Gordes) was founded in 1148 by monks from Mazan and enjoyed several centuries of uninterrupted prosperity. Unusually, the introduction of the commendatory system in 1509 proved a blessing for the abbey, but in 1544 the lay-brothers' wing was destroyed by the Waldensians. There was some rebuilding at the end of the seventeenth century, but the abbey never fully recovered from the depredations. In the nineteenth century it was re-inhabited by a monastic community that became "converted" to seek out and join the Cistercian Order as a result of living within the walls of the ancient abbey. Inhabited by a Cistercian community attached to Lérins, Sénanque is today the most frequently visited Cistercian abbey in France, a jewel of simplicity, intimacy and austere beauty.

SILVACANE (F. M; D. Bouches-du-Rhône; C. la Roque-d'Anthéron) was founded between 1144 and 1147 by Cistercians from Morimond. The site had been occupied by a group of hermits and its early history is unclear. The new community, however, was well endowed and rapidly achieved a comfortable prosperity. In the thirteenth century, Silvacane came into conflict with the powerful Benedictine abbey of Montmajour, and in 1280 it was for a time occupied by Benedictine monks. In 1357 the abbey was sacked and burned, and the subsequent centuries were marked by further problems. The site was abandoned in the course of the eighteenth century, and at the Revolution what remained of the buildings became a farm. Now property of the state, Silvacane has been under restoration and most of the claustral buildings are open to the public, giving an excellent example of Provençale Cistercian architecture from the twelfth to the fifteenth centuries.

SILVANÈS (F. Cît; D. Aveyron; C. Sylvanès) was first established at the Mas-Théron in 1132 by the converted brigand Pons de Léras, and settled by monks from Mazan in 1136. Two years later, the community was transferred to the present site. The abbey owned vast domains and enjoyed great prosperity until the Wars of Religion, when it was pillaged by the Huguenots. It was sold at the Revolution, and the twelfth-century church became a parish church, which saved it from destruction. Several of its windows retain their late twelfth-century forged iron grills, which are a rarity. The eastern cloister range serves as a spiritual, cultural, and musical center.

LE THORONET (F. Cît; D. Var; C. le Thoronet) was first established at Florielle (or Florieyes) in 1136, but because of the poor quality of the land was transferred to the present site in 1176. The abbey was never wealthy, large, or distinguished, though at the beginning of the thirteenth century the abbot of le Thoronet was the well-known troubadour Folquet de Marseille. The commendatory system was introduced at an early date (1435), and in 1614 the abbey was deserted for a time as a result of attacks by the Huguenots. If its history is unremarkable, the gem-like quality of the small-scale architecture, hidden from view until one is before its doors and perfectly adapted to the slope of the site, attracts thousands of visitors annually.

TROIS-FONTAINES (F. Cl; D. Marne; C. Trois-Fontaines) was founded in 1118 as the first daughter of Clairvaux and prospered as a result of rich donations. Its isolated site protected it from the wars, both international and internecine, which ravaged so many other houses. The commendatory system was introduced in the sixteenth century and in the eighteenth century one of the commendatory abbots instituted a program of major rebuilding. At the Revolution, the abbey was sold and most of the buildings dismantled for their stone. Important ruins of the late twelfth-century church (with eighteenth-century embellishments) still stand.

LES VAUX-DE-CERNAY (F. Cl; D. Yvelines; C. Cernay-la-Ville) was founded in 1118 as a daughter of the abbey of Savigny and, with the other Savigniac houses, became Cistercian in 1147. In 1190–95 it was ruined and deserted as a consequence of the French-English wars, but was rebuilt in the thirteenth century. It suffered again in the Hundred Years' War, and yet again in the Wars of Religion when it was burned, but was again restored. One of its abbots, Thibaut or Theobald (✝1247), became a saint; one of its monks, Pierre des Vaux-de-Cernay, wrote a famous history of the Albigensian Crusade; and one of the commendatory abbots, Philippe Desportes (✝1606), was a well-known poet. The immense church still stands up to the level of its vaults, and other abbey buildings and grounds now house a luxury hotel and conference center.

NOTES TO THE TEXT

1. *Exordium parvum*, xvii. Stephen Harding (†1134) was an Englishman educated at Sherborne Abbey in Dorset. After travelling in France and Italy, he became a monk at Molesme and was part of the original group of twenty-two monks who left Molesme in 1098 to found a new community devoted to a stricter interpretation of the *Rule* of Saint Benedict. The traditional date of the foundation of the "New Monastery" (which would later be called Cîteaux) was 21 March (Palm Sunday) 1098. Stephen was, in turn, sub-prior, prior, and finally abbot of the new foundation.

Cîteaux is located approximately sixteen miles (twenty-six km) south of Dijon, the capital of Burgundy. The origins of the name are unclear. It may derive from the Latin *cisterna* (marshy area), from the old French *cistel* (plants which grow in marshy areas), or from the Latin *cis tertium lapidem miliarium* ("this side of the third road marker") along the old Roman road between Langres and Chalon-sur-Saône. The word "Cistercian" comes from "Cîteaux."

2. Bernard de Fontaines (1090–1153) was a young nobleman who entered Cîteaux in 1113 with a group of some thirty friends and relatives. He became abbot of Clairvaux at its foundation in 1115 and governed the abbey until his death. He travelled extensively, and his writings were widely read and had a profound influence on the spiritual life of medieval Europe. At his instigation, kings and princes offered the means to found many abbeys in their domains. His forceful personality and prolific pen attracted hundreds – if not thousands – of young men to the Cistercian Order.

3. Norman Tanner, "Piety in the Later Middle Ages," in *A History of Religion in Britain: Practice and Belief from Pre-Roman Times to the Present*, ed. Sheridan Gilley and W. J. Sheils (Oxford, 1994), p. 71.

4. Benedict (*c.* 480–*c.* 550) was born in Nursia and educated in Rome. Repulsed by the licentiousness of Roman life, he withdrew to a cave at Subiaco and lived as a hermit for many years, eventually – because of local jealousies – moving to Monte Cassino where he established the celebrated monastery that exists to this day.

5. Cluny, founded in *c.* 909/10 by William of Aquitaine in the Rhône valley of the Mâconnais in southern Burgundy, was the chief abbey of a virtual dynasty of Cluniac foundations spreading across Europe. The divine liturgy was the main focus of this Order.

6. Robert of Molesme (*c.* 1027–1111), of a noble Champenoise family, was a relentless reformer, seeking to implement a stricter observation of the *Rule* of Saint Benedict than was customary at this time. He entered the abbey of Montier-la-Celle near Troyes at the age of fifteen and became its prior; he then became abbot of the Benedictine abbey of Saint-Michel at Tonnerre in northern Burgundy (Yonne) and subsequently was prior of Saint-Ayoul in Provins. After these experiences of Benedictine life, Robert joined a group of hermits to whom he introduced

the *Rule*, and with them he founded the abbey of Molesme, but finally left the Benedictine structure in 1098 to found the "New Monastery," later called Cîteaux. He directed the new community until the autumn of 1099 when the pope requested his return to Molesme, which he governed until his death. Robert was succeeded as abbot of Cîteaux by Alberic (†1109) and then by Stephen Harding.

7. Benedict of Aniane (*c.* 750–821) was charged by one of Charlemagne's sons, Louis the Pious (whose name suggests something of his character), to oversee the reform of monasticism throughout Louis' lands. The *Rule* was modified at this time to place a greater emphasis on liturgy, and it was this liturgical emphasis, together with a corresponding decrease in manual labor, which contributed to the Cistercian reform.

8. The seven offices are Lauds (chanted at dawn), Prime (at sunrise), Terce, Sext, None, Vespers, and Compline. The night office, which took place between 1:30 and 3 A.M. (depending on the season), is variously called Vigils, Nocturn, or Mattins, depending on the period and place.

9. It must be remembered that this essay describes medieval customs and is thus written in the past tense, but many of these activities are still practiced in Cistercian (and Benedictine) monasteries today. Others have been modified or abandoned altogether as traditions have evolved.

10. *En. in Ps.* 129.1. Saint Augustine (354–430) was born in North Africa to a pagan father and a Christian mother. He received a Christian education, studied law, and then abandoned religion in favor of literary pursuits. He later became interested in philosophy, travelled to Rome and Milan, and – under the influence of the bishop of Milan – was baptized as a Christian in 387. In 391 he was ordained priest, and was much involved in the affairs of the African church, becoming bishop of Hippo. His writings formed the basis of Christian theology in the West.

11. The original version of the *Charter of Charity* was drawn up by Stephen Harding *c.* 1113. Between 1113 and 1119 this primitive text was elaborated as the Order evolved, and the earliest recoverable version of the text dates from 1119 when it was confirmed by Pope Callistus II. The 1119 version, known as the *Carta caritatis prior*, was superseded by the revised edition of 1152, confirmed by Pope Eugenius III, and known as the *Carta caritatis posterior*.

12. John Eudes Bamberger, "Major Themes in Saint Bernard's Sermons on the Canticle," *Cistercian Studies Quarterly* 33.4 (1998), pp. 415–25. The author is abbot of Our Lady of the Genesee Abbey in Piffard, New York.

13. William (*c.* 1085–1148) was born in Liège and probably studied at Laon. In 1113 he abandoned his studies to enter the Benedictine monastery of Saint-Nicasius at Reims, and five years later he was elected abbot of Saint-Thierry. Subsequently he became a close friend of Bernard of Clairvaux, and

eventually entered the Cistercian Order, becoming a monk of Signy. He played an important role in the condemnation of Abelard, and his writings are masterpieces of twelfth-century spirituality.

14. Isaac (after 1100 – *c.* 1169) was born in England, came to France perhaps *c.* 1130, and eventually became abbot of Stella (l'Étoile), near Poitiers. Hardly anything is known of his life, though his scholastic ideas imply that he must have studied at Paris and/or Chartres. He wrote a short treatise on the Mass, another on the nature of the soul, and a series of sermons. He left Stella *c.* 1167 to establish a small community on the island of Ré, off the coast of La Rochelle, and probably died there *c.* 1169, though neither the place nor the date of his death is certain.

15. Aelred or Ailred (1109–1167), abbot of the great Yorkshire abbey of Rievaulx, was born in Hexham in the north of England. He spent some years at the court of King David of Scotland before being converted to the monastic life. He entered Rievaulx *c.* 1133, was elected abbot of Revesby (in Lincolnshire) in 1143, and abbot of Rievaulx in 1147. His numerous writings are important contributions to English and Cistercian spirituality, and he is often called, with justice, the "Bernard of the North."

16. So important was reading aloud that, unlike other tasks that rotated throughout the community, the *Rule* (ch. 38) specifies that "only those who edify their hearers" were to be chosen as readers.

17. *Carta caritatis prior*, 3.2: Chrysogonus Waddell, *Narrative and Legislative Texts from Early Cîteaux* (*Cîteaux, commentarii cistercienses*, Studia et Documenta 9), (Brecht, Belgium, 1999), p. 276.

18. Idung of Prüfening was a second-generation Cistercian of whose life hardly anything is known. He transferred to the Cistercian Order *c.* 1144 from the Benedictine monastery of Saint-Emmeran in Ratisbonne (Bavaria), although the precise abbey is not known. He is best known for his contribution to the controversy between the Cluniacs and the Cistercians ("Dialogue between Two Monks"), a work which gives many interesting details concerning the daily life of monks and nuns. It is undated but believed to have been written *c.* 1154/55.

19. Hélinand or Hélinant (1160 – *c.* 1230), after studying at Beauvais, became a *trouvère* at the court of Philip II Augustus. He was converted to the monastic life in his twenties and entered the Cistercian monastery of Froidmont, nine miles (fifteen km) from Beauvais, where he became prior. Here he composed a chronicle, a series of sermons and letters, and his very popular *Vers de la Mort*, which had a deep influence on thirteenth-century French poetry. The rhyme scheme of this work was widely imitated and is said to have been invented by Hélinand himself.

20. General Chapter was the annual meeting of all Cistercian abbots, who gathered at Cîteaux every autumn to discuss the Order's business. Very brief summaries – the *Statuta* – give a window into the subjects of their

deliberations, although the résumés are often too abbreviated to provide us with a full understanding of the issue at hand, much less the context.

21. Gregory the Great (*c.* 540–604) was the son of a senator and, in 573, became prefect of the city of Rome. His devout and austere Christianity led him to sell his estates, give the money to the poor, and found seven monasteries. To one of these, in Rome, he retired *c.* 574, but soon afterwards he was sent as papal ambassador to Constantinople. After about seven years he returned to Rome as abbot of his former monastery, and was elected to the papacy in 590. He was a devout Christian, an effective administrator, a strong yet charitable churchman, an important author, and an ardent supporter both of missionary work and the monastic movement. After his death in 604, he was immediately canonized by popular acclaim.

22. The great Benedictine abbey of Saint-Denis was being rebuilt under its abbot, Suger, in the late 1130s and early 1140s, at the same time the Cistercians were building hundreds of abbeys across Europe. The apse of Saint-Denis is usually regarded as the earliest manifestation of Gothic architecture, with ribbed vaults in the ambulatory and great colored glass windows in the chapels, creating a crown of colored light around the chevet.

23. David N. Bell, *The Image and Likeness: The Augustinian Spirituality of William of Saint-Thierry* (Kalamazoo, 1984), p. 110, from the *Ep. ad frat. de Monte Dei*, II.xvi.

FURTHER READING

The literature on Cistercians is vast. Listed here are key or general works in which the interested reader may find further information as well as references to the larger bibliography.

LITERARY SOURCES

Saint Benedict's Rule for Monasteries, translated from the Latin by Leonard J. Doyle (Collegeville, Minn.: The Liturgical Press, St. John's Abbey), or any authorized edition.

The Cistercian World. Monastic Writings of the Twelfth Century, translated and edited by Pauline Matarasso (London: Penguin Books, 1993).

Many of the works of the most important Cistercian writers of the twelfth century are available in English translation as part of the Cistercian Fathers Series (Cistercian Publications, Kalamazoo, MI 49008). To this may be added works of Thomas Merton, the best known Cistercian (Trappist) of the twentieth century.

GENERAL

Michael Casey, *Sacred Reading. The Ancient Art of Lectio Divina*, (Liguori, Mo.: Triumph Books, 1995).

M.-Anselme Dimier and Jean Porcher, *L'Art cistercien. France.* (St.-Leger-Vauban: Éditions Zodiaque, 1962, with subsequent editions).

M.-Anselme Dimier and Jean Porcher, *L'Art cistercien. Hors de France* (St.-Leger-Vauban:

Éditions Zodiaque, 1971, with subsequent editions).

R. A. Donkin, *The Cistercians. Studies in the Geography of Medieval England and Wales* (Toronto: Pontifical Institute of Mediæval Studies, 1978).

Georges Duby, *L'Art cistercien* (Paris: Flammarion, 1976, with subsequent editions).

Peter Fergusson, *Architecture of Solitude. Cistercian Abbeys in Twelfth-Century England* (Princeton: Princeton University Press, 1984).

James France, *The Cistercians in Scandinavia*, Cistercian Studies Series, 131 (Kalamazoo, Mich.: Cistercian Publications, 1992).

James France, *The Cistercians in Medieval Art* (Stroud [Gloucestershire]: Sutton Publishing, 1998).

Terryl N. Kinder, *L'Europe cistercienne* (St.-Leger-Vauban: Éditions Zodiaque, 1997, 2nd ed. 1999). English edition in preparation (Wm. B. Eerdmans Publishing, Grand Rapids, Mich.).

Louis J. Lekai, *The Cistercians. Ideals and Reality* (Kent, Ohio: Kent State University Press, 1977).

Brian Patrick McGuire, *The Cistercians in Denmark. Their Attitudes, Roles, and Functions in Medieval Society*, Cistercian Studies Series, 35 (Kalamazoo, Mich.: Cistercian Publications, 1982).

Martha G. Newman, *The Boundaries of Charity: Cistercian Culture and Ecclesiastical Reform, 1098-1180* (Stanford, Calif.: Stanford University Press, 1996).

Bernard Peugniez, *Routier des abbayes cisterciennes de France* (Strasbourg: Éditions du Signe, 1994).

Roger Stalley, *The Cistercian Monasteries of Ireland* (London and New Haven: Yale University Press, 1987).

Stephen Tobin, *The Cistercians. Monks and Monasteries of Europe* (Woodstock, N.Y.: Overlook Press, 1996).

David H. Williams, *The Cistercians in the Early Middle Ages* (Trowbridge, 1998).

Helen Jackson Zakin, *French Cistercian Grisaille Glass* (New York: Garland, 1979).

Studies in Cistercian Art and Architecture, edited by Meredith P. Lillich, Cistercian Studies Series (Kalamazoo, Mich.: Cistercian Publications, 5 vols., 1982, 1984, 1987, 1993, 1998).

The Cistercian Abbeys of Britain. Far from the Concourse of Men, edited by David Robinson (London: Batsford, and Kalamazoo, Mich.: Cistercian Publications, 1998).

Cistercian Art and Architecture in the British Isles, edited by Christopher Norton and David Park (Cambridge: Cambridge University Press, 1986).

Saint Bernard et le monde cistercien, edited by Léon Pressouyre and Terryl N. Kinder (Paris: Caisse nationale des monuments historique et des sites, 1990, 2nd ed. 1992).

L'Espace cistercien, edited by Léon Pressouyre (Paris: Comité des travaux historiques et scientifiques, 1994); acts of a colloquium held at Fontfroide Abbey in 1993 on Cistercian land management and industry; contributions in English and French.

THIS BOOK was
designed by Eleanor Caponigro.
It was printed and bound by
Eurografica, Vicenza, Italy.
The tritone separations were made
by Robert Hennessey.